MW01483814

The Divine Spark *of*
SYRACUSE

The MANDEL LECTURES in the Humanities
at Brandeis University
Sponsored by the Jack, Joseph and Morton Mandel Foundation

Faculty Steering Committee for the Mandel Center for the Humanities
Ramie Targoff, chair

The Mandel Lectures in the Humanities were launched in the fall of 2011 to promote the study of the humanities at Brandeis University, following the 2010 opening of the new Mandel Center for the Humanities. The lectures bring to the Mandel Center each year a prominent scholar who gives a series of three lectures and conducts an informal seminar during his or her stay on campus. The Mandel Lectures are unique in their rotation of disciplines or fields within the humanities and humanistic social sciences: the speakers have ranged from historians to literary critics, from classicists to anthropologists. The published series of books therefore reflects the interdisciplinary mission of the center and the wide range of extraordinary work being done in the humanities today.

For a complete list of books that are available in the series,
visit www.upne.com

Ingrid D. Rowland, *The Divine Spark of Syracuse*

James Wood, *The Nearest Thing to Life*

David Nirenberg, *Aesthetic Theology and Its Enemies:*
Judaism in Christian Painting, Poetry, and Politics

Ingrid D. Rowland

The
DIVINE SPARK
of
SYRACUSE

Brandeis University Press
Waltham, Massachusetts

BRANDEIS UNIVERSITY PRESS
An imprint of University Press of New England
www.upne.com
© 2019 Brandeis University
All rights reserved
Manufactured in the United States of America
Designed by Eric M. Brooks
Typeset in Albertina by Passumpsic Publishing

For permission to reproduce any of the material in this book,
contact Permissions, University Press of New England,
One Court Street, Suite 250, Lebanon NH 03766;
or visit www.upne.com

Library of Congress Cataloging-in-Publication Data
NAMES: Rowland, Ingrid D. (Ingrid Drake), author.
TITLE: The Divine Spark of Syracuse / Ingrid D. Rowland.
DESCRIPTION: Waltham, Massachusetts: Brandeis
University Press, 2019. | Series: The Mandel Lectures in
the Humanities at Brandeis University | Includes
bibliographical references and index.
IDENTIFIERS: LCCN 2018008864 (print) |
LCCN 2018024205 (ebook) | ISBN 9781512603064 (epub, pdf,
& mobi) | ISBN 9781512603040 (cloth: alk. paper) |
ISBN 9781512603057 (pbk.: alk. paper)
SUBJECTS: LCSH: Syracuse (Italy)—Intellectual life. |
Syracuse (Italy)—Civilization—Greek influences. |
Italy, Southern—Civilization—Greek influences. |
Greeks—Italy—Syracuse. | Plato. | Archimedes. |
Caravaggio, Michelangelo Merisi da, 1573–1610.
CLASSIFICATION: LCC DG55.S9 (ebook) |
LCC DG55.S9 R69 2019 (print) | DDC 937/.8103—dc23
LC record available at https://lccn.loc.gov/2018008864

5 4 3 2 1

To Sallie Spence

And to the memory of Harry J. Carroll Jr.,
on whose office door stood the inscription

Μισέω μνάμονα συμπόταν.

CONTENTS

Color illustrations follow page 66.

A NOTE ON TRANSLITERATION AND TRANSLATION

For the most part, Greek names have
been transliterated in their Latin versions,
because these are more familiar to most readers:
for example, Thucydides rather than Thoukydides
and Plato rather than Platon. Hieron of Syracuse
is an exception, as this is the way classical
scholars generally refer to him.

All translations, unless otherwise specified,
are my own.

You have heard that Syracuse is the greatest
and most beautiful of all the Greek cities.
It is . . . just as it is said to be.
CICERO, *Against Verres*

INTRODUCTION

In a reflective moment, the ancient biographer Plu-
tarch calls the people of Syracuse "outsider Greeks"
(*ektos Hellenon*).[1] As a Roman citizen writing in the sec-
ond century CE, when the empire encompassed vast areas of
three continents, he is still drawing the same distinction between
western and eastern Greeks that Athenian writers were making
more than five hundred years earlier, when Greece was a jum-

ble of warring city-states barely united by a common language. Cosmopolitan as he was, Plutarch—born near the sanctuary of Delphi, where he served for three decades as a priest, and educated in Athens—still identified more with the settlers of the Aegean islands and the coast of Asia Minor, who were bound together by related dialects, than he did with the Dorian Greeks who had sailed west to colonize Syracuse in 733 BCE, twenty years after the traditional founding of Rome. Spoken in Sparta, Corinth, and Thebes, Dorian was the dominant speech of the Greek mainland and the language of the western reaches of the Greek world. From the Athenian point of view, it was a dialect of farmers rather than seafarers (never mind that Dorian Corinth, the mother city of Syracuse, had been one of the great ports of the Mediterranean world ever since the Bronze Age). With language, or so the Athenians believed, came culture: the seagoing Greeks of Attica and Ionia prided themselves on their quick thinking and sophisticated tastes. The great Athenian hero was Theseus, who wore an intricately woven cape as his emblem. The Dorians' champion, on the other hand, was the strong but slow-witted Heracles, whose chosen weapon was a primitive club.

Yet some of those earlier Athenians, like Thucydides and Plato, saw the Greek world differently. Thucydides, who recorded how Syracuse and Athens came into nearly suicidal conflict in the waning years of the fifth century BCE, described their people as the "most like one another" (*malista homoiotropoi*) of any other Greeks.[2] Plato and his brothers, Glaucon and Adeimantus, had close friends from Syracuse who had settled in Athens as permanent residents. When Athens erupted in a virtual civil war and put Socrates, his teacher, to death, Plato traveled south to Egypt and North Africa and then to western

Greece, eager to study mathematics. From there he traveled to Syracuse, a city that raised his hopes for a new kind of human government and then cruelly dashed them.

For the Roman orator Cicero, who had studied in Greece, Syracuse was simply the greatest and most beautiful of all Hellenic cities, surpassing Athens and Corinth—the two gems of mainland Greece. In his opinion the Sicilian capital had long overtaken Athens as the intellectual center of the Greek world, boasting poets; playwrights; and Archimedes, the greatest of all mathematicians since the legendary Pythagoras. To many Roman eyes, if not to those of Plutarch, the western Greeks represented Hellenic culture as certainly as did the Greeks of the mainland, the Aegean islands, or the Ionian coast. But then, the Romans were used to thinking of civic identity on a generous scale: even by Cicero's time, their homeland had expanded from a settlement on seven hills of volcanic rock to encompass large swathes of the Mediterranean and beyond.

For several centuries, therefore, Syracuse, on the southeastern coast of Sicily, ranked as one of the very greatest cities of the Mediterranean. A German map from 1929 (Plate 1) shows a modern city much smaller than the ancient metropolis (only after World War II would Syracuse surpass its ancient dimensions). As archaeological excavations have revealed in recent years, the sparsely built areas that appear on this map between the railroad line, the Roman amphitheater, and the neighborhood of Santa Lucia were all densely inhabited neighborhoods in antiquity (Plate 2). The first Greek colonists, who sailed from Corinth in 733 BCE, settled on the promontory of Ortygia (Quail Island), a spur of limestone joined to the mainland by shifting sandbars. Aside from a few modern interventions, the

street plan of Ortygia still follows the pattern of that original
Greek city (the 1929 map shows the island as it was before the
Fascists intervened), and the streets are often as narrow as their
ancient predecessors (Plate 3). The two largest open spaces in
modern Ortygia, Piazza Archimede and Piazza del Duomo, oc-
cupy the area of the ancient agora, or marketplace, where two
of the city's most important temples provided the focus for
urban life, and still do: the temple of Athena has become the
cathedral of Syracuse, columns and all, while the ruins of the
temple of Artemis sit directly under City Hall.[3] To the west of
Ortygia an ample bay provided a broad, deep harbor; and on
the east, two spits of limestone curved around a smaller harbor.
Two millennia and an endless series of earthquakes have sunk
both harbors beneath the surface of the sea.

After about two hundred years, Syracuse began to expand
from Ortygia to the mainland. The first new neighborhood to
develop was called Achradina (Wild Pear), and until recently,
scholars placed it where the area of Santa Lucia appears on the
1929 map. However, recent excavations in front of the train sta-
tion show that Achradina must have been located instead on
the isthmus connecting Ortygia to the mainland. Just north of
Achradina, a new suburb developed with the name of Tyche
(Fortune); this would have included the southern parts of Santa
Lucia on the modern map. The city's third-century BCE expan-
sion beyond Tyche, in the region of the Greek theater and the
stone quarries on the map, was simply called Neapolis (New
City). This was the great walled city that faced down the Roman
general Marcellus in the siege that lasted from 214 to 212 BCE,
defended by the clever war machines of the city's great mathe-
matician, Archimedes.

At various times, the rivals of Syracuse have included Carthage, Athens, Palermo, and Messina as well as Rome. Ancient visitors included the poets Sappho and Pindar, the playwright Aeschylus, and the orator Cicero, who told his fellow Romans: "You have heard that Syracuse is the greatest and most beautiful of all the Greek cities. It is . . . just as it is said to be."[4] Archimedes and the poet Theocritus were natives. St. Paul stopped to preach there after he was shipwrecked on Malta.

In more modern times, Syracuse has hosted the baroque painter Michelangelo Merisi da Caravaggio; Admiral Horatio Lord Nelson of the British Navy; and the troops of Operation Husky, the Allied invasion of Sicily in World War II. Its fourth-century Greek theater, restored to use in 1914, has become one of the most important theatrical venues in Italy (Plate 4). For all these reasons, Syracuse was designated a UNESCO World Heritage Site in 2005.[5] Yet like the rest of Sicily, the city's population has been shrinking in recent years, part of a general pattern of migration to mainland Italy and abroad.

Fortunate in the beauty of its natural setting, the fertility of its soil, and the mildness of its climate, Syracuse has also fallen victim to terrible tragedies. Sicily sits uncomfortably at the junction of the African and European tectonic plates, with an active volcano, Mount Etna, on its eastern edge. Its landscape, therefore, is as treacherous as it is beautiful. The last major earthquake struck Syracuse in 1693, but the 1908 earthquake that leveled Messina, only a hundred miles to the north, ranks as one of the most destructive in human history and the most deadly ever to strike Europe.

Syracuse has also suffered greatly from human folly. Its eighth century BCE founders drove out the region's earlier in-

habitants, Sicanians and Sicels, many of whom migrated north to the mountainous center of the island. These first colonists, called Gamoroi (sharers in the earth), regarded both indigenous residents and later settlers with a mixture of disdain and hostility, until the festering quarrel between old and new citizens was resolved by having a tyrant warlord rule the city. In 415 BCE, the Athenian navy made a reckless attempt to conquer Syracuse that ended two years later in a cataclysmic defeat. The Athenian attack failed (although it crippled the economy of both cities and brought on political chaos), but it was only the first in an endless series of attempts to master a prize port of the Mediterranean. In 409, Carthage began to make its own move on the region by invading wealthy Selinus, the westernmost of the Sicilian Greek city-states, creating a stream of refugees who settled in Syracuse and further strained the resources depleted by the battle with Athens. For the next two hundred years, the Syracusans watched warily as both Carthage and Rome eyed the city's magnificent ports, fertile countryside, and sophisticated ways, carefully working to maintain a balance between the two powers. At last the Roman general Claudius Marcellus laid siege to Syracuse in 214 BCE, battling one of the greatest military engineers of all time: the elderly mathematician Archimedes, who was tragically killed two years later when the Romans finally breached the city walls. With the fall of Syracuse as an independent kingdom, the whole of Sicily became a province of the Roman Empire. A rapacious Roman governor, Gaius Verres, famously stripped Syracuse of its treasures during his term of office in the first century BCE, but he did not live to enjoy the booty: in 70 BCE, a young lawyer named Marcus Tullius Cicero took him to court for corruption in Rome,

initiating what may be the world's first prosecution explicitly involving cultural property.[6] After the fall of the Roman Empire, Syracuse continued to be governed by outside rulers, from the Vandals, to the Byzantines, to cultured Arab emirs —who moved the capital of Sicily from Syracuse to Palermo. Normans supplanted the emirs, followed by the Genoese pirate Alamanno da Costa and then the Holy Roman Emperor Frederick II, called *stupor mundi* (the wonder of the world) for his manifold talents. When Frederick died in 1250, France and Spain contended for control of eastern Sicily. Spain prevailed, putting Sicily under the charge of a viceroy and bringing on centuries of exploitation and misrule. Based in Palermo and Naples, the viceroys took little interest in Syracuse or the local feudal aristocracy, which maintained its own oppressive grip on the daily life of ordinary people. The vast differences that grew up between Sicily's ruling classes and the masses of poor peasants who worked the island's fertile soil gave rise to a group of middlemen who enforced a rough local justice in the absence of government: the forebears of the Mafia.[7]

In many ways, the creation of a unified Italian state began when Giuseppe Garibaldi landed in Sicily with 1,089 volunteer soldiers on May 11, 1860. Yet unification would ultimately prove disappointing to the people of Sicily and southern Italy. Most of Garibaldi's "Thousand" came from the north, as did most of the men charged with setting up the new national government, with devastating economic and social effects for an area already troubled by centuries of indifferent Spanish rule. Once one of the most advanced regions of the Mediterranean, Sicily (like Naples) lost its ascendancy to Milan, Turin, Florence, and Rome.

Initially, however, Syracusans took an optimistic view of belonging to a modern nation-state. We can still see traces of a building boom in the neighborhood around the train station of Syracuse (where the train line itself provided a powerful symbol of nineteenth-century modernization). Enterprising citizens moved from Ortygia, the ancient center of Syracuse, to orderly, modern city blocks on the mainland, their broad streets designed to offer residents some protection from flying debris in case of earthquake. Originally, the palazzi of these shippers, merchants, and aristocrats had been planned as majestic buildings of three or four stories, many of them taking up an entire block with their enclosed courtyards, but as the economy of unified Italy shifted definitely northward, the money to finish them never materialized. Instead, they rise only two or three stories, with elaborate but unfinished stucco ornamentation and half-finished balconies. Most have been subdivided into smaller units. Meanwhile Ortygia itself became increasingly derelict in the twentieth century.

Fascism carved its way through Ortygia's ancient streetscape by creating a bare piazza around the ruins of the Temple of Apollo and carving through medieval blocks to create the broad Via del Littorio, named for the movement's symbolic bundle of rods and axe. After World War II, this short boulevard, framed by sleek modernist buildings, became Corso Matteotti, honoring the first prominent victim of Fascist violence, the Socialist politician Giacomo Matteotti.

Attempts to bring modern industry to Sicily in the nineteenth and twentieth centuries focused, with tragic results, on sulfur and petroleum. The sulfur mines were already being exploited in the second century BCE, the time of Archimedes,

but the discovery of industrial processing methods in the late eighteenth century intensified production from the 1830s until the late nineteenth century, when competition from Germany and England collapsed the Sicilian market. An early twentieth-century epidemic of powdery mildew on the world's grapevines briefly revived the sulfur business in Sicily (it was used as a fungicide), but the last mines closed permanently in the 1970s, both because of dwindling profits and because the appalling condition of the workers was no longer considered ethically acceptable. The mines ran by having young boys—who were called *carusi* (scabby) and were naked, or nearly so—carry out chunks of sulfur in baskets on their backs, working brutal hours for cruel foremen. Many of the boys were orphans, but some were sold into this hellish service by their impoverished parents. Booker T. Washington, as part of a two-month European tour, visited the Sicilian sulfur mines in 1910 and reported that "the cruelties to which the child slaves have been subjected, as related by those who have studied them, are as bad as anything that was ever reported of the cruelties of Negro slavery."[8]

A series of oil refineries constructed along the coast to the north and west of Syracuse after World War II have proved equally problematic. They produced jobs at the price of ecological devastation and Mafia infiltration, ruining a glorious landscape that figures fundamentally in another of Sicily's leading industries: tourism. Polluted skies and the looming silhouettes of factories mar once spectacular ancient sites like Gela and Megara Hyblaea and the port of Augusta, founded by Frederick II in 1232. Although the petroleum industry is still active, it has never brought in the hoped-for revenues.

An unexpected resource for postwar Syracuse emerged on

August 29, 1953, when a young married couple, Antonietta Giu-
sto and Angelo Iannuso, announced that the plaster Madonna
at the head of their bed had begun to shed salt tears. Their ex-
cited report drew a crowd of neighbors to the couple's tiny
two-room house near the Small Harbor (which would face the
hook-shaped building just above the railroad line in square
D4 of the 1929 map in Plate 1). As news of the weeping Virgin
spread, pilgrims and curiosity seekers streamed into Syracuse
from all over Sicily. The statue had been a wedding present, a
painted plaster bust in high relief of the Madonna clutching
her sacred heart, fixed to a black glass background and hung
over the couple's bed. It wept a total of seven times over the
course of four days, and a local filmmaker managed to capture
one of these episodes before the figure's eyes dried up for good
on September 1, 1953. The local parish priest convened a sci-
entific commission to gather up some of the droplets and ex-
amine them. The commission declared their composition to be
"human tears of an adult person," and after a close examination
of the statue and its frame, the weeping was pronounced scien-
tifically inexplicable. In December 1953, the Sicilian Council of
Bishops officially recognized the Madonna's tears as a miracle.

Weeping Madonnas are a recurring feature of Italian spiri-
tual life, and their acceptance or rejection often hinges on ex-
ternal factors. The Madonna of Syracuse, appearing after World
War II but before the economic boom of the 1960s, served a va-
riety of purposes on a variety of levels. The young couple, like
many Italians, had been both Communist and Catholic, but the
apparition tipped their sympathies toward Catholicism. Their
lower-working-class neighborhood also hosted a Baptist con-
gregation with almost two hundred parishioners—one of the

reasons, their Catholic parish priest would suggest, for the Madonna's tears. On a broader scale, the weeping Madonna helped reinforce the hold of the new, dominant Christian Democratic party against its Communist, Socialist, Monarchist and nostalgic Fascist rivals. The humble young married couple, expecting their first child, sharing the two rented rooms that made up their house with Angelo Iannuso's unemployed brother, provided a perfect picture of faith and fertility. When their son was born on Christmas Day, 1953, they named him Mariano.

Newspapers and radio stations took up the story of the miraculous Madonna on a national level, encouraged by the Christian Democratic government. Angelo Iannuso's initial question to the statue, "Why are you crying, Madonnina?" received a characteristically ambiguous answer in a 1954 radio broadcast by Pope Pius XII:

> Will people understand the arcane language of these tears? Oh, the tears of Mary! On Golgotha they were tears of pity for her son and sadness at the sins of the world. Is she weeping again at the wounds inflicted on the mystic body of Jesus? Or does she weep for so many of her children who have extinguished the life of grace in error and guilt, and who gravely offend the Divine Majesty? Or are they tears of anticipation for the return of so many of her children, one day to be faithful again, but dragged down now by false mirages?[9]

Certainly Antonietta Giusto and Angelo Iannuso drew no personal profit from their weeping Madonna. They died in 2011 and 2004, respectively, still at the same address after fifty-one years of marriage—with four children to bring up, they had

never amassed enough money to move, or to complete the planned second story of their little house. Furthermore, because of the crowds their Madonna drew, they had parted with her only a few days after she began to weep. For years the "Madonna of the Tears" occupied a temporary structure in nearby Piazza Euripide, awaiting a permanent home—a Christian statue in a city square named for an ancient Greek tragedian who performed, as we shall see, a saving role of his own in Syracuse. The modern concrete structure of the Basilica Santuario Madonna delle Lacrime was designed in 1957 by a pair of French architects, Michel Andrault and Pierre Parat, who won the international competition for the commission, but construction began only in 1989. The sanctuary was finally completed in 1994. Pope John Paul II came to Syracuse to preside over its consecration. The architects wanted the church's cone-shaped form to represent the elevation of the human soul, and for the gilded Madonna on its summit to act as the beacon of a spiritual lighthouse, guiding souls (in an ancient Christian image) into the port of faith (Plate 5). Unfortunately for the clarity of their vision, an Italian resident of New York, Italo Marchioni, received a US patent in 1896 for inventing the ice cream cone, and it is to this form, imported to Italy in the early twentieth century, that the sanctuary is most frequently compared.

In addition to the Madonna delle Lacrime, the postwar period in Syracuse brought unchecked urban expansion, most of it involving blocks of cheap, ugly apartment buildings in steel-reinforced concrete financed by massive amounts of dubious money. But the Italian postwar economic boom has also affected Syracuse in positive ways, bringing genuine prosperity to most of its residents and, with prosperity, an increasing in-

terest in preserving and restoring the city's historic buildings. Today, Syracuse qualifies as what the Italians call a Città d'Arte (an art city), a city that attracts tourists through its cultural treasures, and Ortygia especially has lured an increasing number of resident artists.

But Syracuse is really a city of light.

The Divine Spark *of*
SYRACUSE

We have traveled to Syracuse and found Athens.
W. ROBERT CONNOR, *Thucydides*

The Syracusans . . . were most like the Athenians in
character and thus the best at fighting them.
THUCYDIDES

1

PLATO
and
SYRACUSE

We know from Plato's dialogues that he was unusu-
ally sensitive to places; otherwise he could not have
written about them with such evocative power. The
dialogues are set in a variety of venues—dining rooms, court-
yards, gymnasia, a shrine to the nymphs—located in widely
disparate parts of Athens; its port, Piraeus; and its suburbs. The
places his participants mention in conversation range all over

the Hellenic world and beyond. Long before the conquests of
Alexander the Great, the ancient Greeks had already settled
far beyond the contemporary boundaries of Greece, founding
cities along the coast of Asia Minor (modern Turkey) and the
Black Sea; in southern Italy and much of Sicily; and at scattered
Mediterranean ports like Ampurias (or Empúries) in modern
Spain (the Greek Emporion), Marseille in modern France (the
Greek Massalia), and Naucratis in Egypt. Cities like Syracuse in
Sicily and Ephesus on the Ionian seaboard were as central to
Mediterranean commerce as Athens or Corinth. Even Socra-
tes, who famously protests in both the *Phaedrus* and the *Republic*
that he rarely ventures outside the walls of his native city, is said
in the *Symposium* to have fought in the Battles of Potidaea and
Olynthus in distant Thrace, as well as at Delium on the edge
of Attica. Plato, by contrast, is said by ancient writers to have
traveled extensively, to Cyrene in North Africa, to Egypt, and to
southern Italy. He also made three trips to Syracuse, the most
powerful city-state in Sicily, and maintained close friendships
with Syracusans both in Athens and abroad. He was only one
of many illustrious Greeks from Ionia or the mainland who
traveled west to Sicily, attracted by the region's wealth, beauty,
and vibrant intellectual life. Much of the ancient Greek litera-
ture that survives today is Athenian literature, but by no means
all. Syracuse, for example, produced its own illustrious poet,
Theocritus, and its own mathematician, Archimedes, and their
writings have survived to the present. Furthermore, Athens
owed its own cultural ascendancy to the presence of a large, tal-
ented population of immigrants, from the historian Herodotus
of Halicarnassus to the colorful figures who populate Plato's
dialogues. Plato's immigrants include the hotheaded political

philosopher Thrasymachus of Chalcedon, born on the shores of the Bosporus, the Thracian Protagoras of Abdera (born in the same region as Aristotle), southern Italians like Timaeus of Locri, and a veritable spate of Sicilians: the flashy orator Gorgias of Leontini, from just north of Syracuse, as well as several Syracusans—the shield manufacturer Cephalus; his sons Polemarchus and Lysias; and an illustrious temporary visitor, the statesman Hermocrates.

For an Athenian of Plato's generation, Syracuse stood out among Greek cities for a more tragic reason: it was the place where Athens had gambled its status as a Mediterranean power and lost. By changing the fortunes of Athens, Syracuse had changed Plato's life before he ever set foot there. When he finally did come to Sicily, he found danger, new sorrows, and disappointment. Yet for all its troubling memories, Syracuse may also have given Platonic literature two of its most memorable positive images for describing the transforming impact of philosophy on the human soul. They are both images of light. One appears in the famous allegory of the cave from the *Republic*, with its description of what how it feels to emerge for the first time from darkness and captivity into the light of day: "'And if [a prisoner] should come [out of the cave] into the light, with his eyes so full of sunshine, would he be able to see any of the things we call real?' 'Not immediately,' he said" (Plato, *Republic*, 516b). The other image appears in the seventh of the thirteen letters that circulated under Plato's name in antiquity, a letter at least ostensibly addressed to his followers in Syracuse: "[Philosophy] cannot be communicated in words like other kinds of learning; rather, after long familiarity and living with the subject, suddenly, like a light ignited by a leaping spark, it comes to

life within the soul, already self-sufficient" (Plato, *Seventh Letter*, 341 c–d).

Thus philosophy, to Plato, was a fire. Its heat drove him to speak his mind fearlessly, risking his life at home in Athens and abroad in Syracuse. Yet ancient biographers make a point of reporting that Plato died of old age, either in his own bed or during a wedding banquet—proof that, no matter how widely his thoughts might have wandered among transcendent ideas and celestial geometries, he always kept a wary eye on the world around him. In his lifetime, he would experience civil war, tyranny, and slavery as well as wealth and fame and the ecstatic visions that he compared in his *Republic* to "eyes . . . full of sunshine." For that philosophical sunshine and his tireless efforts to communicate it, Plato ranks as one of the most influential people in human history. He is also one of the most elusive. He peoples his dialogues with friends and relatives, but he himself stays carefully in the background. In fact, we know frustratingly little about him, and what we do know has been relentlessly embroidered by legend. Often, however, the legends reveal as much in their own way as the facts do. So also, for this great writer about places, do the distinctive landscapes of Athens and Syracuse, the two cities that seem to have forged his ardent thoughts into a systematic philosophy.

Plato (Plate 6) was born into wealth and privilege, the child of landed aristocrats who could offer him a superb education, the leisure to pursue it, and the political connections to further a civic career when he reached adulthood. His father, Ariston, traced his ancestry back to the heroic Athenian king Codrus; his mother, Perictione, descended from the great lawgiver Solon (ultimately, both lines were traced back to the god Poseidon;

however, we can probably discount the story that Plato's real father may not have been Ariston, but the god Apollo). There were already three siblings in the household to greet his arrival: two brothers, Adeimantus and Glaucon, and a sister, Potone. Adeimantus and Glaucon must have been several years older, as they converse with Socrates in the *Republic* at a time when Plato himself would have been a little boy. Potone seems to have been closer to Plato, and not only in age: she and her husband eventually lived next door to the philosopher in his later years, and their son, Speusippus, would succeed his uncle as head of the Academy. The family was registered in the urban deme of Collytus, beneath the Acropolis and the Areopagus Hill (the modern neighborhood of Theseion), although Plato may have been born on the island of Aegina, where Ariston owned property.[1] Upper-class Athenian husbands were usually ten to fifteen years older than their wives, and Ariston was probably no exception. In any event, he died in Plato's childhood. As a widow, Perictione had no independent legal rights, and it is not surprising to find her making an advantageous second marriage to her mother's widowed brother, Pyrilampes, a friend of Pericles and an illustrious former ambassador to Persia. Pyrilampes already had a famously handsome son, Demus, but he and Perictione also added another son to their household, Antiphon, named for Pyrilampes' own father. If Plato's picture of his half-brother in the beginning of the dialogue *Parmenides* is accurate, Antiphon had studied philosophy but eventually devoted his life to breeding horses, a supremely aristocratic pastime in ancient Greece but not, perhaps, an intellectual challenge.[2]

"Plato" was a nickname. The future philosopher's real name was Aristocles, the same as his grandfather's. Ancient Greek

names spoke eloquently of parents' aspirations for their children. Aristocles, combining the word *aristos* (best) with *kleës* (illustrious), was as patrician as a name could be. So, for that matter, was Ariston, which simply meant "the best." Glaucon (gray) was the color of Athena's eyes and her symbolic owl; Adeimantus meant "fearless."[3] In the *Republic*, Socrates cites a poem (by Glaucon's lover, perhaps not an objective source) describing Glaucon and Adeimantus as "sons of Ariston, godlike clan of an illustrious man,"[4] but the illustrious Ariston's third son, Aristocles, always lived and wrote as *Platon* ('broad' or 'robust'; Plato is the Latin version of his name). Whether the name referred to Plato's broad build, broad forehead, or broad writing style—ancient writers disagree—it certainly suggests an imposing person.[5] But because "Plato" was a nickname he shared with other Athenians (notably a comic poet active in his youth) it lacked some of the elite connotations of Aristocles son of Ariston.[6]

However fortunate his social circumstances may have been, the Aristocles who was called Plato began life during one of the most difficult and discouraging periods in Athenian history. In 431 BCE, seven or eight years before his birth, war had erupted between Athens and Sparta. For two summers in succession, 431 and 430, the dread Spartan army had invaded the Attic countryside, burning houses and crops in hopes of starving its rival into submission. As terrified farmers flocked into the city center for protection, the Athenians, guided by their eloquent general Pericles, built the Long Walls—a protected access to their port of Piraeus, five miles away. Keeping control of Piraeus had become essential, for Athens, surrounded by the stony soil of Attica, depended for survival on imported

grain from Sicily and the Black Sea and timber from Thrace, purchased with silver from the mines of Laurium or exchanged for olive oil (olives grew well on the rugged Attic terrain) and pottery. The space between the Long Walls provided a site for rural refugees to pitch what quickly evolved into a permanent camp. In 429, two years into the conflict, this crush of displaced people and their squalid living conditions brought on an epidemic. The disease killed Pericles and thousands of other citizens. Before the city could recover, the Spartans invaded Attica for a third time, in the summer of 428.

Despite the ravages of war, the Athenians tried to continue their lives as usual, including the religious festivals they celebrated in hopes of winning over the gods and mortal spectators to their cause. The tragic poet Euripides won one of his few first prizes in 431 for *Hippolytus,* just as the war broke out. Sophocles' *Oedipus the King* almost certainly reflects the horrors of the plague of 429 and must have been written either while it raged or shortly thereafter. In 425, a young playwright named Aristophanes won his first dramatic prize at the Lenaia, the winter festival of Dionysus, for *The Acharnians,* a wild, hilarious plea to end the war with Sparta. Plato was probably born the following year, in 424 or 423, when Aristophanes staged a virulent attack in his comedy *The Knights,* on Cleon, the politician who had succeeded Pericles as the most persuasive figure in Athens.

Throughout Plato's infancy, the war dragged on, draining Athens of lives, resources, and money. Triumphant victories for both sides also entailed a series of humiliating defeats. In 425, Athenian soldiers, with Cleon as their general, captured a Spartan garrison at Pylos in southwestern Greece—the invincible Spartan soldiers turned out not to be invincible after all. But

then, in 424, Sparta redeemed its tarnished honor when a brilliant Spartan general, Brasidas, made a lightning-quick march northward to capture the Athenian outpost of Amphipolis, an emporium for metal and timber in the northern region of Thrace. The attack was so quick and clever that it took the Athenian general, Thucydides, by surprise—despite his close ties to Thrace, where he owned land and gold mines and probably had relatives as well. Thucydides managed to keep the port of Amphipolis for Athens, but he did not keep his commission as general; his fellow citizens relieved him of his command and sent him into exile. He began instead to write a history of the war, "convinced that it would be important, and more worth recording than its predecessors."[7] A second battle for Amphipolis in 422 killed both Brasidas and Thucydides' replacement, Cleon, putting the conflict into a hopeless deadlock. In 421, Athens and Sparta struck a fifty-year peace treaty, brokered on the Athenian side by the wealthy magnate and general Nicias, a close friend of Plato's family. Both sides could feel that they had been delivered from a nightmare.

The opening of Plato's *Republic* provides a picture of life during these heady months when Athens hoped at last to return to normality. The dialogue is set around 421 BCE, when a very young Plato would have been playing with Potone in the women's quarters of his house rather than tagging along after his elder brothers.[8] We learn that Glaucon and Socrates have walked the fortified road from Athens to Piraeus, cleared at last of huddling refugees, to see the festival of Bendis, the Thracian goddess of light (a celebration surely intended to cement Athenian ties with the region around Amphipolis). Just as the two decide to head homeward, they are intercepted by a friend from

Piraeus, Polemarchus—the son of Cephalus, an elderly shield manufacturer from Syracuse who had set up shop in the port some thirty years earlier, after Pericles had encouraged him to do so.[9] A contemporary US equivalent to this carefully chosen moment might be setting a scene in New York City circa 1999, before the elections of 2000; the terrorist attacks of September 11, 2001; and the invasion of Iraq in 2003—a time that now seems impossibly innocent.

When Socrates and Glaucon are intercepted by their Syracusan friend, Syracuse, the most powerful city-state in Sicily, had been a crucial Athenian trading partner for several generations, supplying the city with grain in exchange for silver (forged into some of the most beautiful coins ever struck in antiquity), olive oil, and prized Attic pottery; Athenian clay could be spun into fantastic shapes on the potter's wheel, and the glassy sheen of Athenian black glaze was as striking as it was impossible to imitate. Cephalus, as a Syracusan living in Piraeus, belonged to a category known as *metoikoi* (anglicized as "metics"), resident foreigners who obtained some privileges and obligations of citizenship at the price of paying a special annual tax.[10] Athenians also maintained a network of businesses in Sicily: one of them was the general Nicias (of the peace treaty with Sparta), who dealt in silver and slaves and may have been the wealthiest Athenian of all.[11] For Nicias, Cephalus, and other industrialists, the recent war—as Aristophanes was quick to note in his early plays, *The Acharnians* and *The Knights*—had brought huge profits as well as losses: by the time Athens and Sparta had ratified their treaty, for example, the shield factory that Cephalus had set up in Piraeus employed 120 slaves (at the same time, Nicias was leasing out teams of a thousand slaves each).

The war also affected Plato's family directly. Both Glaucon and Adeimantus had done battle in 424 at Megara, west of Athens, probably as cavalrymen but perhaps as bronze-armored infantrymen, facing down none other than the Spartan general Brasidas before he moved north to attack Amphipolis.[12] But the opening of the *Republic* finds the two brothers in a peaceful setting, following Socrates in the company of the sons of Cephalus the shield maker and Nicias the mining magnate. Socrates sets the scene:

> We were returning to [Athens] when Polemarchus, the son of Cephalus, saw us heading home and told his servant boy to run after us and bid us to wait for him. The boy pulled on the back of my cloak, saying, "Polemarchus says to wait." As I turned around, I asked where he was. "Look behind you," [the boy] said, "here he comes; but wait for him." "We'll wait," Glaucon replied. And shortly thereafter Polemarchus arrived, with Adeimantus the brother of Glaucon and Niceratus the son of Nicias, and some other festivalgoers. Polemarchus said, "Well, Socrates, it looks as if you're going back to town."
>
> "Not a bad guess," I replied.[13]

Polemarchus suggests a change of plans by inviting Socrates and Glaucon to stay for dinner in Piraeus and see the torchlight parade that will take place once night falls. Predictably, that dinner leads to a discussion that begins with trying to define justice and continues with an effort to decide upon the ideal form of government for a city-state—in other words, to apply the abstract principle of justice to real life. Plato has chosen the setting for this conversation with consummate care. Its exact

circumstances may be fictional, but the political situation is emphatically not. When Polemarchus and Cephalus offer their hospitality to their Athenian friends, Syracuse and Athens were both democracies with well-established economic ties. Early readers of the dialogue would have understood immediately that the whole scenario, with its leisurely walk, its dinner, its Sicilian and Athenian friends, and its promise of a nighttime festival, belonged to an irretrievable past. A few years later, in 415, the democratic government of Athens would make a series of decisions that reignited the war with Sparta; destroyed the commercial relationship between Athens and Syracuse; and led directly or indirectly to the violent deaths of Nicias, Polemarchus, and Socrates, among countless other soldiers and civilians.[14] Athens emerged so weakened from this new conflict that Sparta was finally able to conquer the city in 404, and because of the instability that this phase of the war provoked, both Athens and Syracuse would run, with dizzying and violent rapidity, through a series of governmental systems: democratic, oligarchic, and tyrannical. The conversation of the *Republic* is set at a moment when all these disasters could still have been averted. Its participants, unknowingly, stand on the edge of a precipice.

Though Plato may first have heard of Syracuse during the balmy days he evokes in Book I of the *Republic*, he first set foot in the city (and composed his dialogue) in the wake of the final Athenian disaster. Like any modern visitor to Syracuse, he could not have walked its streets without remembering the Sicilian expedition, the enterprise that Thucydides, in his history of the war between Athens and Sparta, turned into one of the most harrowing accounts ever written of human folly

(an account, moreover, that Plato surely read). Still, without the Sicilian expedition, Plato would never have become a philosopher in quite the same way. The blinding light of his vision emerged from the deepest darkness.

THE SICILIAN EXPEDITION

By 416, the Peace of Nicias was wearing thin, at least in Athens. Rather than rousing Sparta, however, the restive generals who effectively ran the city's democratic regime decided to pick on a more vulnerable target: the wealthy island of Melos, which had stayed neutral during the war and continued to resist paying tribute to Athens in exchange for nominal protection by the Athenian navy. The Melians were Dorian Greeks, with closer cultural links to Sparta than to Athens. Furthermore, the location of Melos on the western edge of the Aegean placed it physically close to Sparta and its allies. The Athenians feared, not unreasonably, that the island might become a base for the expanding Spartan navy. They therefore stepped up their pressure for an alliance, finally threatening to invade unless the Melians began to pay tribute like their Aegean neighbors. The Melians refused to give in. So, with unexpected savagery, an Athenian force headed by Nicias invaded the island in 416, killed the men, and sold the women and children into slavery. It is not entirely clear whether the civic government in Athens or Nicias and the other generals dispatched to Melos ordered the atrocity, but the invasion was widely regarded as an outrage, not only abroad but within Athens itself. Euripides' *The Trojan Women*, produced in 415, denounced the tragedy of Melos to his fellow citizens by recounting the legendary conquest of Troy from the viewpoint

of its victims. Thucydides' history creates an imagined debate between the Athenians, who proclaim a ruthless doctrine of pure power, and the Melians, who invoke justice, the rule of law, and (at last, in desperation) hope.

Athens had only begun to rampage. Thucydides describes the city's next expansionist scheme with terse precision: "That winter [415], the Athenians resolved to sail again to Sicily with a larger force . . . and conquer it if they could, most of them unaware of the island's size and the great number of its inhabitants, Greek and barbarian, or that they were taking on a war barely smaller than the one against the Spartans."[15]

This daring plan marked the emergence of a charismatic new politician: the young dandy Alcibiades, a nephew of Pericles and a friend of Socrates who never took Socrates' precepts much to heart. Thucydides sums him up as "eager to serve as general, hoping to take Sicily, and Carthage, and reap a fortune both in money and fame. He was esteemed by the townspeople because of his large ambitions, and spent his money on raising horses and other expenditures. More than others, he later brought down the city of Athens."[16]

Alcibiades, in other words, was thinking beyond Greece to North Africa and the Phoenician colony of Carthage, driven by a constant need for money as well as the ravening ambition of a rich, handsome man used to getting his own way.

The expedition's chief opponent was Nicias, whose commercial ties to Syracuse qualified him as a local expert on Sicily but also made him one of the Athenians most likely to suffer if trade turned to war (he also enjoyed close connections to Sparta). Thucydides describes how Nicias tries to dissuade the citizen assembly from voting for the expedition and then tries

to sink the plan a second time by grossly overestimating its costs—only to have the assembly vote enthusiastically for everything he suggests. With glittering pomp, the Athenian fleet of 140 galleys finally sails west, with three generals to guide it toward Syracuse: reluctant Nicias; eager Alcibiades; and Lamachus, a magnate and successful general whose pomposity Aristophanes had lampooned in *The Acharnians* ten years before.

With a tragedian's skill, Thucydides spins out the tale of how, within two years, the expedition—which involves the largest, most potent Greek fleet ever to set sail—disintegrates into a total rout. He begins with a portent. A few days before the fleet departed, vandals throughout the city defaced the protective statues called herms, square posts topped by a head of the god Hermes and decorated at their midpoints with the carving of an erect phallus (Plate 7). Decorous Thucydides says that the faces were smashed, ribald Aristophanes says it was the phalluses; given the fact that both features protruded, we might conclude that both were probably damaged. It was a dreadful omen, because Hermes protected travelers. Blame for the vandalism quickly settled on Alcibiades, whose attitude to religion was not distinguished by its reverence. In a last-minute planning session for the expedition, one of his political enemies accused him both of smashing the herms and of profaning the mystery cult of Eleusis together with other rich young aristocrats, including Charmides, Plato's maternal uncle (though one scholar has suggested that the real culprits were Athenian women).[17] Alcibiades requested a trial before the fleet's departure, but momentum for the expedition was too great to put it off. He set sail with Nicias and Lamachus, only to find that when the fleet reached the coast of Sicily, an official ship

from home, the superswift *Salaminia*, was waiting to arrest him and bring him back to Athens. Instead, Alcibiades escaped to Sparta, throwing the whole expedition and Athens itself into predictable confusion.

After this ominous beginning, Thucydides shows how the attack on Syracuse goes from bad to worse, until he focuses on the straggling remnants of the Athenian force in 413—exhausted, hungry, thirsty, and aimless, retreating westward from Syracuse over the hills and gullies of the Sicilian countryside. Nicias, in excruciating pain from kidney stones, can barely guide them. When they reach the banks of the Assinarus River, the desperate soldiers wade right into the water, drinking it in in desperate gulps as the Syracusan cavalry mows them down: "When they reached the river, they rushed in without any order, each one trying to cross first, although the attacking enemy make the descent difficult. Pressed in together, they jostled and trampled each other. Some fell on their own spears, others, tangled in their own gear, were swept downstream. The Syracusans, stationed on the opposite bank of the river, which was a sheer drop, attacked the Athenians from above as they drank greedily, struggling confusedly in the hollow of the riverbed. The Spartan allies stormed down the bank and killed most of the men in the river, quickly polluting the water, but they kept on gulping down the bloody water mixed with mud, and many of them fought each other for it."[18]

Today, that fateful bank of the Assinarus marks one boundary of the glorious baroque city of Noto, better known for its marzipan pastries than for the carnage of 413 (Plate 8). Some of the survivors simply wandered aimlessly, stunned by what they had witnessed, and then drifted away. But most of the

Athenians and their allies, including the two generals, Nicias and Demosthenes, were brought back to Syracuse to endure further misery. The generals were given a summary trial and executed. The remaining prisoners were thrown into the limestone quarries above the city (Plate 9). As Thucydides writes:

> At first the Syracusans dealt harshly with those in the quarries. Enclosed in a narrow, hollow area, out in the open, many of them developed strange new diseases, tormented in the daytime by the sun and the stifling air, and at night by the sudden change to the chill of autumn. With so little space, those who had died of their wounds or of exposure or similar causes lay heaped up among the living, and the stench was unbearable. At the same time, they suffered constantly from hunger and thirst (for eight months they received one cup of water a day, and two of grain). Indeed, they experienced every imaginable evil that could have befallen them in such a place. For some seventy days, they all lived together under these conditions; then all but the Athenians and their Italian and Sicilian allies were sold into slavery. It is hard to make an accurate count of those taken captive, but they were certainly no fewer than seven thousand. This turned out to be the greatest action of the entire war, and from what I have heard, the greatest action in the history of the Greeks, the most glorious for the victors and the most wretched for the defeated, who were vanquished in every respect, with huge losses to infantry, ships, and everything else, and only a few among so many ever returned home. These are the things that happened in Sicily.[19]

Syracuse sits on a series of limestone promontories. We come to know them well from Thucydides' descriptions in his history: Epipolae, the heights overlooking the city, guarded by the fort called Euryalus (broad); the peninsula of Plemmyrium (flood tide), the island of Ortygia. Most of the city's buildings and its fortification walls have been made of this local stone since Syracuse was founded in 733 BCE. The quarries were dug on the outskirts of the ancient settlement, and the modern city has had to expand around their artificial crags and hollows. Today, they have become lush gardens, where roses and delicious Valencia oranges thrive in the protected microclimate (Plate 10). In Plato's day, however, the quarries were still actively worked by teams of slaves and prisoners. From Thucydides' account, it sounds as if the survivors of the Sicilian expedition were simply corralled in the quarries rather than put to work there. Yet Plutarch, writing in the second century CE, tells a remarkable story about these Athenian captives in his *Life of Nicias* (including a moving description of traumatic shock soothed by singing tragic songs):

> Most of the Athenians perished in the quarries from disease or bad diet, allotted two cups of barley a day and one of water, and not a few were stolen and sold, or escaped by passing themselves off as house slaves. Those who were sold as house slaves had a horse branded on their foreheads; they had to endure this indignity as well as slavery itself.
>
> They also say that many of the survivors who reached home went to pay their heartfelt respects to Euripides, explaining that some of them had been released from

slavery by teaching their owners whatever they could re-
member of his poetry, and others were offered food and
drink for singing his choruses as they wandered after the
battle.[20]

Two of the ancient quarries are still easily accessible: the
Latomia dei Cappuccini (quarry of the Capuchins) to the east
of the city, and the Latomia del Paradiso (quarry of paradise) to
the north, right next to the ancient theater. In spite of the lush
and fragrant gardens, most of them planted four centuries ago,
the stones still seem imprinted by memories of the Sicilian ex-
pedition. In 1631, the Roman adventurer Pietro della Valle cap-
tured their haunting combination of beauty and melancholy:

> During the day, we went to see the Capuchin convent out-
> side the city, in the gardens of which there are cliffs and
> deep hollows, because all this terrain, which is of stone,
> was excavated in ancient times to extract building stones;
> and inside you can see gorgeous columns, all cut in one
> piece, and places where they could have carved out oth-
> ers. And yet, in those deep, dark valleys of the hollows,
> gardens and trees have been planted, which bear beauti-
> ful fruit, and this made me marvel, because I saw some in
> places that cannot possibly ever be touched by the sun, so
> low is the level of the ground, and so closely is it enclosed
> by rock on every side. These are the Quarries, where the
> Athenians were imprisoned, who surrendered to the Syr-
> acusans after losing so many battles on land and sea, as
> Thucydides tells us.[21]

THE AFTERMATH

News of the defeat in Sicily demolished morale in Athens long
before the stragglers began to return with their tales of horror.
For months, the city feared a direct attack from Syracuse, not
realizing the terrible damage the failed campaign had actually
managed to inflict on the Sicilian metropolis. Instead, it was the
Spartans who took advantage of the disaster, invading Attica
once again in the winter of 413, burning crops and olive trees
and driving refugees back within the Long Walls. This time,
however, rather than returning home after the raid, the Spar-
tan king built a permanent fortress in the rugged hill coun-
try of Decelea and settled in for a year-round campaign. From
this vantage point, strategically sited near the silver mines of
Laurium, he promised freedom to any slave willing to desert.
Thousands of brutally exploited miners took up the Spartan
offer, bringing one of the mainstays of the Athenian economy
to a virtual halt.[22]

Plato, therefore, spent his teenage years in a city under siege.
With the silver mines no longer functioning; the grain trade
with Sicily interrupted; the fleet decimated; and thousands of
able-bodied men dead, wounded, or traumatized, Athens was
no longer the same rich imperial power it had been before its
fleet sailed off to Syracuse. There were still the remains of an
empire, including a formidable fleet stationed in the eastern Ae-
gean, but the days of aggressive Athenian expansion were over.
The city had brought the calamity on itself, but no one wanted
to bear the blame for such a collective fit of hubris. Under Spar-
ta's watchful eye, the Athenians began to fling accusations at

one another. The historian Luciano Canfora has called the experience of the next few years "the Athenian civil war," an effective
description of the Athens in which Plato came of age.[23] It was
still a city with tentacles spread throughout the Greek world,
but now its empire began to crumble, one city-state at a time.

The events of the next decade would reserve important roles
for Socrates and several of his followers: Alcibiades, Xenophon,
and Plato's uncles Charmides and Critias. Politically, they belonged to every position on the political spectrum: Socrates
served the Athenian democracy loyally; Alcibiades exploited it
as a demagogue; and Xenophon, Charmides, and Critias, despite their closeness to Socrates, favored a more restricted ruling class and admired Sparta even as the Spartan king sat in his
fortress waiting to subdue Athens once and for all. But in spite
of their political persuasions, all of these men were members of
the same wealthy, close-knit social circles and exhibited, on occasion, the same excesses of privilege: Charmides, like Alcibiades, had been exiled for mutilating the herms and profaning the
mysteries of Eleusis, and so had Plato's brother Adeimantus.[24]
Political discussions within Plato's family during this troubled
period must have been not just heated, but incandescent. The
war with Sparta—especially the failure of the Sicilian expedition—struck them all, as it struck the rest of the city, with the
force of an earthquake.

The disaster in Sicily was blamed not only on individuals
—Nicias and Alcibiades—but on Athenian democracy itself,
with most of its offices filled by lot, drawn from a citizen roll
that has been estimated to contain the names of 30,000 to
50,000 people ranging in status from wealthy landholders
to galley rowers. In 411, two years after the disaster in Sicily, a

group of the city's wealthiest citizens staged a coup, reducing the governing body to an official 400 members—although the actual number of people involved in governing may have been as few as 50.[25] Alcibiades seems to have played a crucial role in turning the takeover from talk to action; by this time, after advising the Spartans on how to defeat the Sicilian expedition, he had shifted his allegiance to Persia and was commanding his own fleet in the eastern Aegean. He had encouraged the Athenian oligarchs to act by promising them Persian aid against Sparta, whose forces were still firmly entrenched in the Attic fort of Decelea and steadily gaining the upper hand over Athens in a deadly war of attrition.

Our information about the events of 411 is shadowy, in part because Thucydides and Xenophon, our chief sources, may have been personally involved in the coup, as was the playwright Sophocles.[26] Yet the oligarchy proved so unpopular that it expanded the number of voting members to 5,000, and then —after a few months of this arrangement, which Thucydides praises as the best government Athens ever had—the city returned to its direct democracy.[27] The oligarchic interlude may have been short, but for Plato's family it was significant: the 400 recalled his uncle Charmides from exile. A few months later, the 5,000 recalled Alcibiades, busy with his fleet off the Ionian coast. The prodigal son returned to Athens in 407, but by the next year he was back in the eastern Aegean, fighting naval battles against Sparta and its allies. With the defeat of the Athenian attack on Syracuse, the active theater of the war with Sparta had shifted from Sicily in the west to Ionia in the east. And it was in Ionia that Athens suffered the definitive blow to its survival in 405, when the Spartan navy destroyed the remnants of the

once-supreme Athenian fleet at a place called Aegospotami. Its trade routes in tatters and its economy in ruins, the city finally surrendered to Sparta in 404. Plato was about twenty years old and had begun, like his brothers, to follow Socrates.

THE THIRTY

The Spartan conquest of Athens was exceptionally lenient by ancient standards. Rather than sacking the city and its port, killing men, and enslaving women and children, the victors imposed a puppet government of thirty longtime Spartan sympathizers that included Critias, a cousin of Plato's mother. The Thirty in turn appointed ten supervisors for the Piraeus, including Plato's uncle Charmides. Their regime lasted for only thirteen months, but those months made an indelible impression on Plato's life. With terrifying dedication, the Thirty confiscated property, made arrests for specious reasons, killed their perceived enemies, and promoted their favorites. Critias, a talented, cultured man, proved the most enthusiastic tyrant of all. Among many other victims, he hounded the sons of the Syracusan shield maker Cephalus, eager to put his hands on their properties in Piraeus, from the shield factory to the family's houses. Polemarchus, who hosts the dinner party that sets the scene for the *Republic*, was arrested on trumped-up charges and forced to drink hemlock. His family was forbidden to hold a funeral, for that might have led to an uprising. His younger brother, Lysias, escaped but lost his fortune. When Lysias returned to Athens, he earned a living, and enduring fame, as a professional orator and speechwriter; rhetoric was still something of a Sicilian specialty.

The Thirty did not last long. They became the Twenty-Nine when Critias turned against his able but slippery colleague Theramenes, denounced him in a public assembly, stripped him of his citizenship, procured his arrest, and forced him, without a trial, to drink hemlock. At the same time, Critias also urged his talented young relative to enter public life, but Plato could see what was happening clearly enough to avoid it. The *Seventh Letter* describes his feelings:

When I was young I felt as many others did: as soon as I became my own master, I thought, I would enter immediately into civic life. But then certain political developments befell the city, namely the overthrow of the much-maligned [democratic] constitution, and the changeover to the government by fifty-one men, eleven in the city center, ten in Piraeus, with each of them charged with administering affairs in the marketplace and among the residents of the city. Thirty of them were appointed governors with absolute powers. Some of them happened to be members of my family and acquaintances of mine, and straightaway they called me in to invite me to take part in their affairs. I was so young that I found nothing strange in this: I thought that they were going to lead the city out of an unjust way of life into a just one, and so I paid close attention to what they might do. And I saw how in a short time men began to refer to the former constitution as pure gold. Furthermore, they sent an elderly friend of mine, Socrates, whom I wouldn't be ashamed to call the most just of the men of that time, to arrest another citizen on a capital charge, so that he would be forced, like

it or not, to participate in their doings. But he would not obey them, and dared to risk everything rather than become a partner in their unholy deeds. And when I saw all these things, and others equally serious, I was outraged, and withdrew myself from the evils of that time.[28]

Withdrawal would prove one of Plato's most effective tactics, in life as in literature. He withdrew from politics; he withdrew from Athens; and he withdrew from his own dialogues, although he peopled them with his friends and family members. In the treacherous political conditions of postwar Athens, he had learned early on that discretion saved lives.

The most active opposition to the Thirty came from the rowers and sailors in Piraeus, where Critias had appointed Plato's uncle Charmides to a special ten-man commission charged with keeping order, and where he confiscated the shield factory of Cephalus along with all the properties owned by the Syracusan's sons. In 403, a street battle broke out in Piraeus between democrats and supporters of the Thirty. Both Critias and Charmides were killed, and the Thirty, already reduced in numbers and torn by vicious internal dissent, disintegrated shortly thereafter.

When the Athenians insisted on returning to a democratic government, the Spartans did not object. Their once-mighty rival was no longer a military threat. After an initial burst of shared enthusiasm, the citizens of the newly reinstated democracy began to use the restoration of their power as a way to settle old scores. One of those old scores was with Socrates, whose former pupils had taken such a conspicuous part in the recent series of political upheavals. The elderly philosopher

was put on trial for "corrupting the youth" and "introducing new gods."[29] The *Seventh Letter* provides a quick account of the effects on Plato:

> In not much time the Thirty fell, and their whole constitu-
> tion with them, and once again, but more slowly, the de-
> sire to engage in public life and politics began to pull me
> in. In those confused times there were still many things
> happening that would outrage anyone, and it was no sur-
> prise that in the middle of a revolution some people took
> excessive revenge on their enemies. Yet many of the peo-
> ple returning from exile used great moderation. But some
> misfortune decreed that some of those in power would
> bring our friend Socrates to trial on the most unholy of
> charges, a charge that fit Socrates least of all men. Some
> prosecuted him for impiety, the rest condemned him and
> killed him, the very man who had refused to participate in
> the unholy arrest of one of their exiled friends.[30]

It was then that Plato decided to travel rather than enter pub-
lic life and to concentrate, apparently, on the stable truths of
mathematics rather than the shifting world of politics—in
which several members of his family had played an ambigu-
ous part at best, and old family friendships had turned into
bitter rivalries. Over the course of twelve years, the war with
Sparta, the Sicilian expedition, and their aftermath had turned
a bright, promising public citizen into a far more subdued,
wary individual with few illusions about human nature. Plato
had seen how power could turn his uncles into tyrants, how a
shift in political systems could put courageous men to death,
and how women and children suffered for events over which

they had no control. Pericles, in the funeral oration that Thu-
cydides ascribes to him, may have claimed that women should
keep silent, but it is hard to believe that Perictione and Potone
were silent in family discussions when the Platonic dialogues
argue so consistently for women's place in governing the state.
For Plato, amid the agonies of Athens, philosophy had become
something far deeper than an intellectual system. It had be-
come his way of living life. His goal as a philosopher was the
same goal he seems to have nurtured as a young, ambitious cit-
izen: to create a world ruled by justice and, above all, goodness.

Μισέω μνάμονα συμπόταν.
I hate a drinker with a good memory.
AN ANCIENT SICILIAN SAYING,
QUOTED BY PLUTARCH,
Quaestiones convivales

2

PLATO
in
SYRACUSE

In 388 or 387, the forty-year-old Plato sailed into the port of Taras (modern Taranto), the onetime Spartan colony that had grown in its three centuries of existence into one of the most populous cities in the Greek world, with perhaps as many as 100,000 inhabitants.[1] A prosperous trading post, thanks to its flat, fertile hinterland and splendid harbor, Taras was also an intellectual center, especially for

mathematics, and Plato hoped to learn more about that subject from the city's most illustrious natural philosopher, Archytas. Southern Italy had been a center for mathematical studies since about 530 BCE, when the great Pythagoras set sail from his native Samos, off the coast of Asia Minor, and headed for Egypt and western Greece—as far as he could remove himself from the Samian tyrant Polycrates.[2] A figure who quickly achieved legendary status, Pythagoras was credited in antiquity with inventing the term *philosophia* (love of wisdom) to describe his mixture of intellectual inquiry and spiritual contemplation (though in fact the term may have been coined by Plato).[3] Archytas, who was probably about the same age as Plato, was an important political figure in Taras, elected to the position in his own city—*strategos*, or general—that Pericles held in Athens. He was also a teacher in the Pythagorean tradition, drawing students from every part of the Greek world, and it was in his school at Taras that Plato met an aspiring philosopher named Dion of Syracuse.

Then twenty-one, Dion was handsome, intelligent, and passionately in love with philosophy. Plato was smitten. As he would later write: "For Dion, who was eager to learn everything, and especially my own ideas at the time, listened with such keen attention as I have never experienced with any other young person, and he resolved to live his life differently than most Italians and Sicilians, loving virtue, rather than luxury, as the greatest of all the pleasures."[4]

From Taras, the two proceeded to Syracuse, invited by Dion's brother-in-law, the tyrant Dionysius I. The city Plato saw on that first visit had long since recovered from the Athenian expedition of 415–13 and the decade of political chaos that followed

afterward.[5] Now Syracuse was expanding rapidly, spreading outward from its historical center on the peninsula of Ortygia to sprawling suburbs on the mainland, all laid out in neat city blocks (a process of urbanization that would repeat itself in the nineteenth and twentieth centuries). To serve this expanded population, the Syracusans had moved their agora from its ancient site on Ortygia to the isthmus that divided the city's two harbors from one another, the Great Harbor on its ample bay, bristling with the masts of merchant ships, and the exclusive Small Harbor, its docks and the very seafloor outfitted in extravagant marble by Dionysius.

Seven or eight years older than Plato, Dionysius had begun life as a public clerk in the democratic government of Syracuse.[6] In the aftermath of the failed Athenian invasion, he had attracted attention as a persuasive speaker in the assembly and an able military strategist, at a time when Syracuse faced threats no less potentially devastating than the Athenian fleet in 415. After the destruction of the Athenian forces in 413, virtual civil war had broken out within the city, as supporters of Athens clashed with supporters of Sparta, splitting the democratic government into factions. At the same time, Carthage, which controlled the northwest corner of Sicily (Plate 11), saw the perfect opportunity to increase its territory and began mounting raids against its nearest neighbors, Segesta and Selinus. If fear of Athens had subsided in Syracuse after 413, fear of Carthage had not: the siege of Selinus in 409 had killed 16,000 people outright. Five thousand more were sold into slavery, and 2,500 made it to neighboring Acragas to spread the news that Carthage was on the march. Furthermore, the conflict with Athens had torn Syracuse into factions. In 411, while Athens faced its oligarchic

coup, the democratic government of Syracuse had expelled Hermocrates, the city's ablest politician, despite (or because of) his heroic service. Years before the Athenian invasion he had warned his fellow Sicilians about the rise of Athenian power, and from 415 to 413 he had led the Syracusan defense—enough, in the long, sorry history of ancient Greek factional strife, to earn him exile from the city he had done as much as anyone to preserve. In 408, after three years spent wandering the Mediterranean, Hermocrates gathered together a group of survivors from Selinus and reestablished a settlement there in defiance of Carthage, using it as a base from which he plotted to take control of Syracuse himself. After his attempt at a coup failed in 408, he was killed in a street fight in 407.[7]

The death of Hermocrates left Dionysius an opportunity to begin consolidating his own grip on power, using fear of Carthage as a lever. In 406, the Carthaginians moved eastward down the Sicilian coast from Selinus to conquer Acragas, setting their sights on Gela, with Syracuse next in line. Dionysius made an impassioned plea before the Syracusan people's assembly, the democratic government's ruling body, to send an army against the Carthaginians. Not only did the assembly grant his request, but they also appointed him general, with supreme command over the armed forces. By 405, Dionysius had used that authority to impose himself as the city's sole ruler. To consolidate his position further and placate nostalgic democrats, he married the daughter of Hermocrates and married his sister to Hermocrates' brother-in-law; the name of the renegade general, so admired by both Thucydides and Plato, was still important in Syracuse.[8] Sparta's conquest of Athens in 404 brought added stability to its Dorian allies throughout

the Greek world and certainly strengthened Dionysius' grip
on Syracuse, as well as burnishing Hermocrates' posthumous
reputation—for it was Hermocrates who had provided both
the Spartans and the Syracusans with such excellent advice in
fighting off the Sicilian expedition.

In 402, Dionysius began a massive program of public works,
circling Syracuse with a fortification wall that extended for
twenty-seven kilometers, from the narrow neck of Ortygia to
the dizzy heights of Epipolae, where the Athenians and Syr-
acusans had battled each other in 414 by building stone bas-
tions. Two fortresses secured the system: the outlying structure
called Euryalus, at the summit of Epipolae, and the new bastion
that Dionysius set down squarely in the middle of the isthmus
leading to Ortygia. He made this new stronghold his chief res-
idence. Within its forbidding walls, or beneath their shadow,
Plato began to teach Dion the philosophy he later described as
"my own ideas at the time."

Despite his youth, Dion already held a privileged position
in the tyrant's household. His father, Hipparinus, had served in
the army that first brought Dionysius to power, and Dionysius
had married Dion's sister after the death of his first wife. Shock-
ingly to his fellow citizens, he had also married another woman
at the same time; adding insult to injury, she was a native of
Locri on the Italian mainland, a city normally hostile to Syr-
acuse. Plato moved, therefore, into an opulent but unconven-
tional household.

Plato has left us a substantial literature, but he reveals almost
nothing about himself. Unlike Greek writers of the Roman Em-
pire, such as Aelius Aristides and Pausanias, Plato barely men-
tions his travels or the sights he saw, any more than he mentions

his feelings. He says nothing, therefore, about the sight of the smoking Mount Etna looming above Epipolae, or the sprawling old temple of Apollo at the entrance to Ortygia (Plate 12), one of the oldest Doric temples—if not the oldest—in the Greek world. We can presume that he wandered up the gently rising slope of Ortygia's Sacred Way past the temple of Artemis to reach the temple of Athena, set at the highest point of the little peninsula, the heart of the original colony of Syracuse. On Athena's temple roof, a gilded statue of the goddess acted as a beacon to sailors, and perhaps Plato had seen it catch the sun's rays as the ship he and Dion had sailed on from Taras pulled into the Small Harbor. From the temple of Athena and the area of the old agora, the Sacred Way of Ortygia descended toward the spring of Arethusa, a freshwater source at the edge of the salty Mediterranean. The ancients believed that the Alpheus, the river that flows through Olympia on the Greek mainland, plunged under the sea to pursue the nymph Arethusa, emerging again in Syracuse, where he mingled his waters with hers in a perpetual pledge of love for this corner of Sicily (Plate 13).[9] Was the fourth-century spring filled with papyrus plants and waddling white ducks as it is today, paradoxically thriving right next to the salt water? Over the centuries, the violent earthquakes that rock this seismic region have apparently shifted the spring's waters from fresh to salt and back again to fresh. There were certainly statues and offerings in Plato's time that no longer exist in the shrine of Arethusa, and the spring in those days, with its miracle of fresh water bubbling up by the seashore, was thought to be a genuinely holy place. Almost two hundred years before Plato arrived there, in 476 BCE, the poet Pindar praised the charms of Ortygia:

Holy refuge of Alphaeus,
Ortygia, sprig of glorious Syracuse,
Alcove of Artemis, sister of Delos [that is, Apollo],
From you a sweet-worded song rushes forth
To sing great praise of swift-footed horses,
A gift to the Zeus of Mount Etna.[10]

Did Plato visit the theater, the place where Aeschylus had produced his tragedy *The Women of Etna* around 475 BCE, and where Dionysius made the speech before the people's assembly that earned him his military command in 406? The carved rock seats that still fill every summer with contemporary theatergoers date from after the time of Aeschylus and Plato, but the place itself is the same, consecrated for 2,500 years to Dionysus, the god of wine and the special protector of every ancient Greek named Dionysius (as well as every modern English-speaking Dennis).

Just beyond the limestone shell of the theater of Syracuse, a narrow path plunges into the quarry that is now known as the Latomia del Paradiso and is distinguished by a remarkable physical feature: a sinuous cave that follows the course of a long-gone underground river (Plate 14). A tiny opening at its summit admits a weak glimmer of light. Its walls, like the rest of the quarry, show the marks of the bronze tools that chiseled out the building blocks of ancient Syracuse. Because the cave curls in on itself, it produces extraordinary sound effects, and an immemorial local legend says that Dionysius, who used the quarry as a prison, used to sit on the ground above the tiny hole in the ceiling of the cave and eavesdrop on the prisoners' conversations. When another visitor to Syracuse, the Italian painter

Michelangelo Merisi da Caravaggio, came to the quarry in 1608, he compared its resonant structure to the shape of the human ear. It has been known ever since as the Ear of Dionysius.

Did Athenian prisoners shelter inside the Ear of Dionysius in 413? We do not know for certain, but no visitor since the fifth century BCE can avoid thinking about them. The Roman author Claudius Aelianus, writing in the early third century CE, tells another remarkable story about these quarries and the prisoners confined to them: "The Sicilian quarries were by Epipolae, six hundred feet long, two hundred feet wide. There were people in them who had spent so much time there that they had married and borne children. And some of their children had never seen the city, so that when they went into Syracuse and saw horses in harness and teams of oxen, they ran away shouting; that is how terrified they were. The most beautiful of the caves was named after Philoxenus the poet, who is said to have composed his *Cyclops*, the most beautiful of his poems, while he was imprisoned down there, indifferent to the vengeance and judgment of Dionysius—Philoxenus could create music even under such circumstances as those."[11] This cave of Philoxenus is almost certainly what Caravaggio would call the Ear of Dionysius in 1608, the most spectacular natural feature in the dramatic landscape of the Syracusan quarries.

A remarkable cave also features in a dialogue by Plato, a dialogue that takes place in the house of a Syracusan merchant in Piraeus only a few years before the Sicilian expedition sailed off to disaster from that Athenian port. That dialogue is, of course, the *Republic*. The cave comes up when Socrates is conversing with Glaucon:

"Now then," I said, "compare our nature's state of enlight-
enment, or lack of it, to this experience: imagine people
living underground in a kind of cave, with a long entrance
extending toward the light along the whole interior. They
have been there since childhood, with their legs and necks
in shackles, so that they are fixed in one place and can only
see in front of them, unable to turn their heads because of
their restraints. Above and behind them at a distance is
the light of a blazing fire, and between the prisoners and
the fire runs an elevated path. Imagine a low parapet built
along it, like the platform of a puppet theater that rises in
front of the audience, with the show taking place above it.
 "I can see it," he said.[12]

Socrates' description is particularly well drawn if we imagine
shadow puppets rather than marionettes (for which the ancient
Greeks used a different word than the one Plato uses here).[13]
The modern Greek tradition of Karaghiozi shadow puppets is
usually traced back to the Ottoman empire (Karaghiozi is Turk-
ish for "black eyes"), but this form of entertainment has de-
veloped in many different cultures, and there is no reason to
suppose that it did not exist in ancient Greece—modern Greek
puppeteers certainly think it did.[14] The next part of Socrates'
account sounds even more like a Karaghiozi show:

 "Now imagine people passing alongside the parapet carry-
 ing every kind of object just above its edge, and statues of
 people and animals in stone and wood and every other
 medium, and think of some of these carriers talking, and
 others keeping silent."

"It's a strange image you describe," he said, "and these are strange prisoners."

"They are like us," I replied. "In the first place, do you think that these people have seen anything of themselves or one another except the shadows the fire has projected onto the wall in front of them?"

"How could they?" he said, "if they have been prevented their whole lives from moving their heads?"

"What about the objects being carried by? Wouldn't it be the same situation?"

"How do you mean?"

"If they could converse with one another, wouldn't they think that they were referring to real objects [rather than projections] when they talked about what they saw?"

"They would have to."[15]

After a few more exchanges that set the scene more clearly, Socrates begins to reach the point of his striking image:

"If one of these people were suddenly released from bondage and forced to stand up, turn his head around, and walk out to look at the light, wouldn't doing all these things be painful, and wouldn't the glare make it impossible to see what had been visible in the shadows? . . . And if someone dragged him into the light of the sun, wouldn't he suffer and complain about being dragged, and when he emerged into the light, with his eyes full of sunshine, wouldn't he have trouble seeing a single thing that we regard as real?"[16]

Slowly and carefully, Socrates draws out the contrast between life in the cave and life in the light of the sun, and how

eyes accustomed to darkness and bodies accustomed to immobility can change their habits only step by step, comparing this physical process of enlightenment with the way that education in philosophy gradually elevates the soul from considerations of the here and now to thoughts that transcend the physical world, educating it to "see the light" in a more transcendental sense (Plate 15): "'This image, dear Glaucon, applies to everything we have just said, with the visible realm comparable to the prison, and the fire inside the cave to the power of the sun. And if you understand the upward ascent and vision as the soul's ascent toward the realm of ideas, you won't disappoint my expectations.'"[17]

Unlike his brother Glaucon, whom he portrays in this dialogue as an eager young man, by the time Plato wrote the *Republic* he was a man well over forty, who had seen just such a strange cavelike prison and strange prisoners in the quarries of Syracuse.[18] The resonant acoustics he describes for his imagined cave have an exact earthly equivalent in the Cave of Philoxenus, and the amusing story about how Dionysius threw Philoxenus into prison may well have been current when Plato came to Syracuse with Dion in 387.

In the first century BCE the historian Diodorus of Sicily passed on the story of Philoxenus in prison with evident relish. For Dionysius, once he had consolidated his power, not only built fortresses but also collected people he hoped could help restore the cultural life of Syracuse. These cultural ambitions explain why he had sent Dion off to Taras and welcomed the arrival of Plato. He also invited poets to his court from all over the Greek world, the more famous the better. Philoxenus stood at the top of his list: the poet came from Cythera, an Aegean

island that claimed to be the birthplace of Aphrodite, and specialized in the choral odes to Dionysus called dithyrambs. It is no surprise that Dionysius would have fostered Dionysiac poetry, when his own name proclaimed his parents' devotion to the god of wine and drama. Furthermore, dithyrambs were performed as song and dance by people in elaborate costumes; in Athens as well as Syracuse, commissioning new dithyrambs, preferably from famous poets, provided the perfect excuse to put on a lavish show.

Like the Roman emperor Nero after him, Dionysius composed poetry with great enthusiasm. In addition to composing new works in his honor, his court poets were also supposed to help him correct and revise his own compositions (and to praise them), with the result, Diodorus claims, that the tyrant boasted more about his songs than his military victories. One evening, at an after-dinner symposium, Dionysius performed some of his works and asked Philoxenus to give an honest opinion. The verse, Diodorus assures us, was *mochtheros* (awful), and Philoxenus, hoping to be a constructive critic, said as much. But "when he replied forthrightly, the tyrant took offense at what he had said, accused him of speaking slanderously out of jealousy, and ordered some of the servants to haul him straight off to the quarries."[19]

The next day, thanks to urgent petitioning by other poets, Dionysius relented. He released Philoxenus from the quarry, invited him to yet another dinner that ended with a symposium and poetry recitation, and again asked his distinguished guest for a frank opinion. Philoxenus said nothing except to order Dionysius' guards to take him back to the quarries.[20] Finally the two came to an understanding: the next time Dionysius recited

his verse, Philoxenus pronounced them *eleeina* (which could mean either "moving" or "pitiful"). Dionysius, in his vanity, took the description in the flattering sense.[21]

Plato had his own experience with the vanity of Dionysius, whose aptitude for philosophy turned out to be on an entirely different order than Dion's. Plutarch's *Life of Dion* tells of yet another dinner party ending with the tyrant's idea of a learned symposium:

> When the gathering focused on discussing manly virtue, and especially courage, Plato declared that everyone exhibited more courage than tyrants. Turning from this subject to justice, he taught that the life of the just is blessed, wheareas that of the unjust is miserable. The tyrant responded to these speeches as if he had been convicted by them, and hated the way the whole company marveled at the man himself and were charmed by what he said. At last, he was irritated to the point that he lost his temper and asked [Plato] why he had come to Sicily. Plato replied that he had come searching for a good man, at which point Dionysius replied, "By the gods, you don't seem to have found one yet." Most of the people in Dion's circle assumed that that was the end of the tyrant's anger, and quickly they put Plato on a ship bound for Hellas with Pollis the Spartan.[22]

Dionysius, however, was still fuming. He gave secret orders to Pollis, the ship's captain, to assassinate Plato en route, like Rosencrantz and Guildenstern in *Hamlet*—or at least to sell him into slavery. Pollis chose to sell his passenger and make some money on the affair, and Plato ended up on the block

at the slave market of Aegina, the island just off Athens that
may have been his birthplace. There he was recognized and
redeemed by the philosopher Anniceris of Cyrene, who sent
Plato back to Athens as a free man. When the Plato's Athenian
friends tried to repay his liberator, Anniceris replied that Athe-
nians were not the only people worthy of providing for Plato.[23]

Perhaps Dionysius was not so bad a poet after all. According
to some ancient authors, in 367 he entered a play, *The Ransom of
Hector*, in the Lenaia festival at Athens, the winter celebration of
his patron god Dionysus. When word came to Syracuse that his
play had won first prize, Dionysius—at least according to Di-
odorus—became so gloriously drunk that he died on the spot,
or shortly thereafter.[24] In contrast, Plutarch claims that he was
poisoned by his doctors at the instigation of his son, Diony-
sius II, who was eager to exchange the position of crown prince
for that of king.[25]

Plato's *Seventh Letter* describes his early days in Syracuse with
Dion as an idyllic experience: "How, then, can I declare that my
arrival in Sicily was the beginning of everything? In keeping
company with Dion, only a youth at the time, I dare say that
in disclosing to him in words what I thought was best for hu-
mankind, and counseling him to put these things into action,
I failed to realize that I was unwittingly contriving a future
means of overthrowing tyranny. Dion, moreover, eager for all
kinds of learning and especially for my teachings, listened with
a keen intensity I have never seen in any of the young people I
have come across."[26]

After Plato's departure in 387, Dion became the elder ty-
rant's closest advisor, with special responsibility for dealings
with Carthage. Twenty years later, when Dionysius was on his

deathbed, Dion—a mature man with two decades of diplo-
matic experience—hoped, at least briefly, to be acclaimed king
himself. But Dion was only a brother-in-law, not a blood rela-
tive. The crown passed instead to Dionysius' spoiled son by his
Locrian wife, Dionysius II.

On his return to Athens, Plato took over a famous old gym-
nasium, garden, and shrine sacred to the obscure cult hero
Hecademus, the place we know as the Academy (Plate 16).[27] The
Academy was already well known in the Greek world when
Plato was a young student. It was one of the first Athenian land-
marks to greet travelers on the road from southern Greece, a
verdant sanctuary where visitors could exercise, leave an of-
fering for Hecademus, attend classes, and hold learned discus-
sions under the canopy of ancient trees. (Still green and shady,
the Academy is now in a down-at-the-heels suburb near ugly
off-ramps of the National Road, the successor to the ancient
roads that have led since the Bronze Age to Megara, Corinth,
and Sparta.) It was one of the places that the young Plato fre-
quented, both for the teachers who gave lessons there and for
the gymnasium, where he excelled as a wrestler.

Once Plato took charge of the Academy, it became thor-
oughly associated with his name and his activities there. He
took in students, including at least two women, from all over
the Greek world. In these familiar haunts, he taught, con-
versed, and composed his dialogues, including the *Republic*. In
this new kind of writing—the philosophical dialogue, his own
invention—we can see what a great dramatist Plato would
have made if events in Athens had turned out differently. His
evocative descriptions of places and states of mind remind
us that he continued to write lyric poetry throughout his life.

His writings also return again and again to the theme of Syr-
acuse and the Syracusans he had known. The previous chap-
ter has shown how the dramatic setting of the *Republic* takes
Socrates, Plato's brothers, their friend Polemarchus, and his fa-
ther Cephalus back to the time before the Sicilian expedition,
one of the great traumas in Athenian history and Plato's life.
The dialogue's conversation about ideal political systems takes
place before the Sicilian folly had cast the Athens into the civil
war that killed Polemarchus, Charmides, Critias, and eventu-
ally Socrates. The transformation of Critias from uncle to ty-
rant and the experience of living under real tyranny in Syracuse
give Plato's dialogue the bite of bitter memory. After making its
trenchant comparison of different systems of government, the
Republic's Socrates concludes that no human government can
rule justly until the people who make up that government have
truly understood what justice is.[28] The middle-aged Plato had
seen little justice in his own life, and it is no wonder that Soc-
rates in the *Republic* declares that it is to be found not in the im-
mediate world around us, but in a realm beyond the reality of
the senses.

There are tantalizing similarities between the *Republic* and
Sophocles' final play, *Oedipus at Colonus*, which was composed
shortly before his death in 406/405 and produced posthumously
in 401. The tragedian was old enough to be Plato's grandfather
(he was around ninety when he died), but they both understood
that after 413, the city they as they had known it would never
return. In Sophocles' last play he returns to the character most
closely associated with him, Oedipus, the king of Thebes. In
Sophocles' great *Oedipus the King* (the Greek title, *Oidipous tyran-
nos*, literally means Oedipus the Tyrant, a word that already had

strongly negative connotations), probably written during the plague of 429, Oedipus learns that he has murdered his father and married his mother; to save his community from his own curse, he blinds himself (stopping the evil eye from doing further harm) and sends himself into exile. In *Oedipus at Colonus*, the elderly Oedipus finally comes to rest in a rural area of Attica, Hippeus Colonus—Sophocles' own district. Oedipus asks the residents where he is, and they answer:

> You have come, stranger, to the strongest fastness
> of this land of beautiful horses
> Bright Colonus, where the clear, sweet warble of the
> nightingale
> Haunts the green glens,
> bearers of wine-colored ivy,
> And the leafy, untrodden precinct of the god
> The shady home of a thousand fruits,
> Untouched by winter storms. There
> Dionysus the bacchant
> Always treads, roaming with
> His divine nursemaids.
> Beneath a froth of heavenly dew
> The narcissus flowers forever in beautiful clusters,
> the ancient garland
> Of the two Great Goddesses,
> And the golden-dawning crocus.
> Nor do the sleepless wandering springs of Cephisus
> Ever diminish their flow;
> Each day, always, they bathe the burgeoning plain
> In pure moisture

Over the broad-swelling earth.
Nor do the Muses withhold their dances,
Or Aphrodite who holds the golden reins.
And there is something that I have never heard
In Asia or the great Dorian Peloponnese—
A plant undefeated, self-sufficient,
The terror of enemy spears
That flourishes best of all in this land,
The gray leaf of the nurturing olive,
Zeus Morius watches over it,
And gray-eyed Athena.[29]

By 406, the Hippeus Colonus that the chorus describes is pure idea; the real countryside had been torched every year since 415 by the Spartan garrison based in Decelea. The only person who can truly see the district, and the Athens it represents, is blind Oedipus, who must in some profound sense stand for Sophocles.

The *Republic* that Socrates and Glaucon begin to create is also a pure fantasy, a republic that famously abolishes the family and puts women in charge of the state as well as men. Considering what some of the men in Plato's family had done when entrusted with Athens, we can sympathize with his new regime. In real life, however, Plato remained a loyal son, nephew, brother, and uncle. His nephew Speusippus, the son of his sister Potone, followed him around the Academy as he himself had once followed Glaucon and Adeimantus in the train of Socrates. Speusippus was an eager student but also one with definite opinions of his own—a quality of intellectual independence that Plato, as a teacher, seems to have prized and cultivated. One

of his other favorite students was an equally distinct personality, a wealthy dandy from the Thracian seaside town of Stagira, a son of the court physician to the king of Macedon. His name was Aristoteles. We call him Aristotle, but Plato simply called him "the Mind."[30] Like Speusippus, Aristotle was more interested in the physical world than in his mentor's realm of shining ideas; for the two students, who grew to maturity in a more temperate, peaceful Athens than the city Plato had known, the sun provided brilliance enough.

Speusippus and Aristotle may not have shared Plato's sense of urgency about reforming politics through philosophy, but in Syracuse there was someone who did: Dion.

At the death of Dionysius I in 367, Dion failed to succeed the tyrant as king, but he kept his position as counselor under Dionysius II (who had apparently never thought much about what it meant to rule Syracuse). Now, however, Dion was an elder statesman rather than a younger brother-in-law, and with that added authority he tried to train Dionysius in Platonic principles. Dionysius showed signs of interest, and Dion finally convinced him to invite Plato back to Syracuse. The *Seventh Letter* describes Plato's own misgivings, as well as the hopes that finally induced him to make the trip:

> With this straightforward purpose Dion persuaded Dionysius to send for me, and sent his own message begging me by all means to come as quickly as possible, before someone else fell in with Dionysius and turned him toward some way of life other than the best. He begged me saying the following, even if it is a bit lengthy to relate: what better time, he said, are we waiting for than the

present, with its heaven-sent fortune? He noted their influence over Italy and Sicily, and his own power in the region, and the youth and eagerness of Dionysius, and remarked what a great interest he had in learning and philosophy, and how his own nephews and household were so easily influenced by my own words and way of life, that they were ideally suited to persuade Dionysius, and hence there was a greater hope now than ever that individuals could be both philosophers and the rulers of great cities. These, and a host of other arguments along the same lines, were his exhortations, but as for my own feeling about converting the young people, I was afraid; their enthusiasms for such things are quick and contradictory. On the other hand, I knew that the nature of Dion's character was sober for his age and moderate. And so I pondered and hesitated, wondering whether I should go and obey Dion's summons, and how. Yet at the same time, there was a weighty counterargument: if we were ever going to try putting our ideas about laws and politics into action, we should do it now. If I could truly persuade even one person, I would have accomplished a world of good.[31]

The experiment ended in something less than a triumph for philosophy. In the first place, Plato was disgusted with the voluptuous life in the Syracusan court. From the *Seventh Letter* we learn that Athenians were used to having only one large meal a day, but in fertile Syracuse there were two, and other pleasures besides:

Once I had arrived, that so-called blissful life of Italian and Syracusan banquets pleased me not at all—liv-

ing by stuffing oneself twice a day and never spending a
night alone, and all the other preoccupations that go with
such a way of life. With habits like those, cultivated from
youth, no mortal born under heaven ever grew any wiser
—no human nature has ever been so wondrously com-
posed—and no one will become more temperate, and
the same applies to every other kind of virtue. And no city
can remain stable under the rule of law when its citizens
are convinced that everything should be pursued to ex-
cess, and that they need exert themselves in nothing but
feasting, drinking, and Aphrodite. Cities like this are con-
demned of necessity to pass from tyranny to oligarchy to
democracy in an endless cycle, for the people in charge of
such cities can't even endure hearing the mention of just
and fair government.[32]

In a similar vein, Plutarch begins his three books of *Table Talk*
by quoting a Sicilian saying, *miseô mnamona sympotan*—good
Dorian Greek for "I hate a drinker with a good memory."[33] The
parties in Syracuse must have been as raucous at the height of
the Roman Empire, when Plutarch wrote, as they had been at
the time of Plato.

The participants in Plato's *Symposium* decide to drink mod-
erately, "only for enjoyment."[34] We can only wonder what kind
of food, and how much, was served at the Academy. We can
guess, though, that the person who reintroduced Plato to the
modern world in the fifteenth century, the Florentine physician
Marsilio Ficino, did not share his idol's attitudes about nutri-
tion. A good Tuscan, and hence descended from the prover-
bially sleek Etruscans, Ficino had a thoroughly Italian attitude

toward food—he loved it—including a predilection for that
Sicilian specialty, almond cookies.[35]

Dionysius, an avid partygoer, soon became bored with Di-
on's endless stream of advice. He claimed to have intercepted
correspondence between his tiresome uncle and the Cartha-
ginians that suggested a joint conspiracy, affording him the
perfect excuse to banish Dion from the city in 366. Why listen
to Dion's version of Plato anyway, when he had Plato in person?
The *Seventh Letter* describes the deteriorating situation in terms
that could apply to many a dysfunctional human gathering:

> When I arrived—there's no need to draw out the story
> —I found the court of Dionysius full of factional strife
> and slander about Dion's attitude toward the tyranny. I
> defended him as best I could, which was little enough,
> and about four months later Dionysius accused Dion
> of plotting against his kingship and embarked him on
> a small ship, shamefully expelling him from Syracuse.
> After this all of Dion's friends feared that one of us might
> be accused of taking part in Dion's plot and punished.
> As for me, word went out in Syracuse that I had been
> put to death by Dionysius as the instigator of everything
> that had happened. When Dionysius heard that this was
> how we felt, he began to worry that some worse calam-
> ity might arise from our fear, so he began receiving every-
> one graciously. In my own case he kept trying to soothe
> me, and told me to take heart, and begged me to stay at
> all costs. He had nothing to gain by my fleeing, but only
> from my staying, and that is why he made such an ef-
> fort to detain me. But we know that the requests of ty-

rants are always mixed with an element of compulsion, and so he contrived to keep me from setting sail, setting me up in an apartment on the acropolis from which no sea captain could ever have borne me away, not just because Dionysius would have blocked him, but because no one would have made a move unless he issued a specific order to carry me off. And there was not one merchant, or border guard, or anyone at all who, if they saw me walking alone, would have hesitated to seize me and lead me straight back to Dionysius—for one thing, it had been proclaimed, contrary to what had been said earlier, that Dionysius was wonderfully hospitable to Plato. How were things in reality? One must speak the truth. As time went on, he became more and more welcoming as he got to know my character and habits, but he wanted me to praise himself more than Dion, and to be considered a closer friend of mine than Dion, and was extraordinarily eager to prevail over him. But the best way for this to happen, if it were to happen, he rejected: namely by learning, and listening to lessons about philosophy, becoming familiar with its teachings and keeping company with me, rejecting the words of slanderers and not getting bound up in worrying about everything Dion might be doing. I put up with it all, keeping in mind the purpose for which I had come: seeing whether he could arrive at a true passion for the philosophical life. But he won in the end with his persistence.[36]

Plato's pleading on Dion's behalf so annoyed Dionysius that he confiscated his uncle's estates and gave Dion's wife in

marriage to another man (himself the son of an outrageous bigamist, the tyrant had no illusions about matrimony). Using all his persuasive charm, Plato finally managed to escape from the madness of Syracuse. He was reunited with Dion in Athens, where the latter joined the company at the Academy and struck up a close friendship with Speusippus.[37]

However, Dionysius had not given up on his own Platonic education. He pleaded with Plato to return, finally sending a ship to Athens in 361 or 360 to fetch the philosopher back.[38] This time, according to Plutarch, Plato returned with Speusippus in tow, a first indication that he might be grooming his nephew to be his successor.[39] Dion, however, stayed behind. According to the *Suda*, a tenth-century Byzantine dictionary, Plato entrusted the Academy in his absence to a student, Heraclides of Pontus.[40]

Plato's third sojourn in Syracuse began with a great welcoming fanfare, but it quickly turned sour. Plutarch's *Life of Dion* tells the hair-raising tale:

> At last Dionysius sold Dion's estate and kept the money. He moved Plato from an apartment in the garden to live among the mercenaries, who hated him because he was always trying to convince Dionysius to abandon tyranny and live without a bodyguard. When Archytas and his associates learned that Plato was in such danger, they sent a galley with an embassy straightaway, demanding that Dionysius release him and claiming that they themselves had pledged surety for his safety when he set sail for Syracuse. Dionysius tried to deny his hostility by hosting banquets and making friendly preparations for Plato's

departure, and at one point leaned over to him and said,
"Well, Plato, you'll be able to accuse us of many dire mis-
deeds in front of your fellow philosophers." Smiling, Plato
replied "May the Academy never suffer such a shortage of
topics for discussion that we'll have to think of you." They
say that this was Plato's parting shot, but Plato's own ac-
count does not agree in every respect.[41]

From Athens, Dion plotted his own return to Syracuse.
When he finally did come back in 357, it was with an army. Tak-
ing advantage of a moment when Dionysius was out of Syra-
cuse on a visit, Dion succeeded in seizing control of every part
of the city except the royal residence at the isthmus, which re-
mained loyal to the tyrant. Dionysius rushed back to recap-
ture his residence and held it for a short while, lobbing missiles
from his ramparts at the city around him and trying repeat-
edly to negotiate a treaty with Dion and the other Syracusans.
At last Dionysius left the citadel to his son Apollocrates and
sailed off to Locri on the Italian mainland, just across the Strait
of Messina from Sicily—the Scylla and Charybdis of Homer's
Odyssey (later Greeks supposed that Scylla, the seven-headed
man-eating monster, was really a band of Etruscan pirates, and
the whirlpool Charybis clearly represented the strait's treach-
erous currents). There, in his mother's native city, Dionysius
would rule as tyrant until 343, when he returned to Syracuse
—only to be unseated two years later by the heroic Timoleon
of Corinth, who united Sicily against Carthage and might have
provided Plato with a real philosopher-king.[42]

Sadly for Dion, his tenure in Syracuse would not last long,
and he never transformed the city into an ideal Platonic re-

public. He was assassinated by his officers in 354. Plato and his nephew heard the news in Athens.

The *Seventh Letter* is ostensibly Plato's response to yet another invitation to return to Syracuse. Plato's authorship of the text is debated, but if it is not by Plato himself, it was composed shortly after the philosopher's own lifetime, perhaps by members of the circle of Speusippus, and it provides a knowledgeable account of the events in Sicily.[43]

Strikingly, the *Letter*, like the *Republic*, includes a long digression about the nature of true knowledge and, again like the *Republic*, it includes a powerful image of light: "[Philosophy] cannot be communicated in words like other kinds of learning; rather, after long familiarity and living with the subject, suddenly, like a light ignited by a leaping spark, it comes to life within the soul, already self-sufficient."[44]

The spark of philosophy, the letter goes on to suggest, had started a fire in Dion's soul, but the soul of Dionysius was hopelessly trapped within the man's own know-it-all arrogance. Yet Dion, too, was ensnared by worldly concerns, despite all his education. As an exile, the *Letter* reports, he met Plato in Olympia and tried to solicit his mentor's help in overthrowing the tyranny of Dionysius, exhibiting the same faults: "And now some baleful spirit has fallen upon them in lawlessness and godlessness and, above all, the boldness of ignorance, from which all evils take root and flourish, and finally bear their bitter fruit; now for the second time ignorance has destroyed everything."[45]

Yet Plato—the real Plato—did return to Sicily in his imagination. Two of his latest dialogues, the *Timaeus* and *Critias*, and the possible plan for a third dialogue, *Hermocrates*, evoke memories of the *Republic* and its political discussion among Socra-

tes, Plato's brothers, and their Syracusan friends in the port of Piraeus.[46]

The *Timaeus* introduces a new cast of characters to converse with Socrates. Timaeus of Locri, who dominates the dialogue, is otherwise unknown. He is introduced as an astronomer, and it is surely no coincidence that he hails from the city where Dionysius II spent his years of exile from Syracuse. The second speaker is none other than Hermocrates of Syracuse; like Timaeus, he is staying in the guest quarters of the third participant, Critias, who is almost certainly Plato's notorious relative, the onetime student of Socrates and future ringleader of the Thirty Tyrants.[47] The dramatic date of the dialogue should therefore be around 409 BCE, when Hermocrates is returning to Sicily from his travels in exile to the eastern Mediterranean, and Athens has returned to democratic government after its brief oligarchic upheaval in 411.

By 409 the war with Sparta was toiling toward its agonizing end, but Athens persisted in celebrating the public religious festivals that brought in visitors from the entire Greek world. In March of that year, Sophocles would win the first prize for tragedy at the City Dionysia, the greatest of the Athenian dramatic festivals, with *Philoctetes*—a play set during the last stages of another war, the siege of Troy. And in June, at least within the microcosm of Plato's dialogue, the western Greeks Timaeus and Hermocrates have come, like so many foreigners before and after them, to see the Panathenaia, the festival of Athena Polias, the protectress and namesake of the city of Athens.[48]

The first paragraphs of the *Timaeus* pointedly evoke the *Republic*. The two Athenians and their two western Greek visitors have agreed to spend several days in conversation. Socrates

reminds them, "What I said yesterday about the constitution of a state basically had to do with what kind seemed best to me, and what kind of men took part in it."[49] His summary parallels some of his discussion in the *Republic*, but not all—he is evidently reporting a different conversation on the same subject, with different participants. Now both Syracuse and Athens are in a state of civil war, and both are threatened at the same time by powerful outside enemies: Carthage in the case of Syracuse and Sparta in the case of Athens, with the specter of Persia looming over them to the east.

Critias begins to tell the story of how Athens defeated the city of Atlantis nine thousand years earlier, but then the speakers shift their attention to the astronomer Timaeus, who traces human nature, and hence human government, back to the structure of the universe. Critias will resume the story of Atlantis in the unfinished dialogue that bears his name. We can only guess what Hermocrates might have discussed had Plato lived to write the dialogue that was to have borne his name. In the *Timaeus*, as in the *Republic*, we are presented with individuals and cities whose imminent doom is evident to us, but not to the participants. As Catherine Zuckert points out, "Like the all-night meeting of the eleven in the *Republic*, the gathering of known opponents of the Athenian democracy at Critias' house to discuss how Socrates' proposals could be put into practice has the look of a conspiracy."[50] Yet rather than showing a successful cabal in action, Plato gives us two participants, Hermocrates and Critias, whose real-life conspiracies in Syracuse and Athens will lead them to ignominious deaths. They are outstanding citizens who will both be felled as street fighters in the very cities they had been called upon to govern, one as a

democrat, the other as an oligarch. It is Socrates, in his stead-
fast loyalty to democratic Athens, who dies a hero in Plato's
work. At least as Plato portrays him, Socrates obeys the rule of
law as a higher principle, even when obedience means suffer-
ing the fallible application of that law by fallible citizens. Like
the otherworldly Timaeus, who lives in the realm of cosmic ge-
ometry, Socrates sees by the light of the sun. Hermocrates and
Critias, whether in Syracuse or Athens, are confined to caves of
their own choosing, chasing after fleeting shadows.

For Plato, Syracuse—with its beautiful natural setting, its
material and cultural wealth, and its personal and historical con-
nections—became another Athens, similar to the city where
he lived but just distant enough to provide him with a larger
perspective on the world and humanity's place in it. Like Al-
pheus in pursuit of Arethusa, Plato found his own way to Syr-
acuse, though he followed a fiery path of ideas rather than an
underground river. And in so doing he, too, binds the Greek
mainland forever to the West.

3

ARCHIMEDES
in
SYRACUSE

In 214 BCE, Marcus Claudius Marcellus, consul of Rome, had gathered his fleet off the shoreline of Syracuse, the largest city in Sicily, ready to attack. He estimated that it would take about five days to conquer the city and secure it as a stronghold against Hannibal, the Carthaginian general who had crossed the Alps three years before and now controlled most of southern Italy. As Marcellus would

soon discover, however, his plans for Syracuse had omitted one crucial factor: a little old man named Archimedes. For the next two years, Marcellus would try to starve Syracuse into submission, because a simple assault had proved impossible almost immediately. Every time his troops moved in, they triggered some diabolical machine perfectly tailored to the situation: close range or long range; by land, sea, or air. The Roman general could only marvel at the inexhaustible cunning of the elderly defender who maneuvered behind the walls of Syracuse, always ready with some new mechanism to sling stones, bolts, and slugs of lead in every direction, at every type of attacker. Marcellus may have known of Archimedes' reputation as a mathematician, but he was totally unprepared for Archimedes' genius as a military engineer. We know something about the siege of Syracuse from the historian Polybius, writing two generations later, who would have heard the story from descendants of the Romans who had borne witness to the amazing display. Evelyn Shuckburgh's translation of 1889 is still vivid as well as accurate:

> Archimedes had constructed artillery which could cover a whole variety of ranges, so that while the attacking ships were still at a distance he scored so many hits with his catapults and stone-throwers that he was able to cause them severe damage and harass their approach. Then, as the distance decreased and these weapons began to carry over the enemy's heads, he resorted to smaller and smaller machines, and so demoralized the Romans that their advance was brought to a standstill. In the end Marcellus was reduced in despair to bringing up his ships secretly under

cover of darkness. But when they had almost reached the shore, and were therefore too close to be struck by the catapults, Archimedes had devised yet another weapon to repel the marines, who were fighting from the decks. He had had the walls pierced with large numbers of loopholes at the height of a man, which were about a palm's breadth wide at the outer surface of the walls. Behind each of these and inside the walls were stationed archers with rows of so-called "scorpions," a small catapult which discharged iron darts, and by shooting through these embrasures they put many of the marines out of action. Through these tactics he not only foiled all the enemy's attacks, both those made at long range and any attempt at hand-to-hand fighting, but also caused them heavy losses.

Then, whenever the enemy tried to work their *sambucae* [literally, "harps"; a kind of siege ladder], he had other engines ready all along the walls. At normal times these were kept out of sight, but as soon as they were needed they were hoisted above the walls, with their beams projecting far over the battlements, some of them carrying stones weighing as much as ten talents [323 kilograms!], and others large lumps of lead. As soon as the *sambucae* approached, these beams were swung round on a universal joint and by means of a release mechanism or trigger dropped the weight on the *sambuca*; the effect was not only to smash the ladder but to endanger the safety of the ships and of their crews.[1]

Most terrifying of all was a crane called "the hand." Every time the Roman ships drew near the Syracusan sea wall, these

"hands" swung out of their emplacements and dumped stones on the heads of the marines that splintered the decks. Then, as the terrified crews looked on, each "hand" lowered a grappling hook, seized the bronze beak on the ship's prow (all ancient battleships had this feature, which acted as a battering ram in combat) or part of the gunwale, and began to pull upward. Polybius tells us that Marcellus was mustering some of the largest and heaviest vessels in the Roman navy, quinqueremes, galleys with five banks of rowers (Athens, by comparison, had set out to conquer Syracuse in triremes, with three levels of rowing benches). But the "hand," with the help of compound pulleys, could lift a quinquereme high enough to upset its balance and flood the decks with water. Once the warship had tipped, dumping its cargo of heavily armed marines and flailing galley rowers into the sea, the "hand" let its cargo drop, and sink beneath the waves. (8.6)

Polybius draws several conclusions from the siege of Syracuse. Superb natural defenses had always helped repel invaders, but Archimedes enhanced these natural features immeasurably by thinking through and preparing in advance for every kind of attack. As Polybius observes:

> The strength of the defences of Syracuse is due to the fact that the city wall extends in a circle along high ground with steeply overhanging crags, which are by no means easy to climb, except at certain definite points, even if the approach is uncontested. Accordingly Archimedes had constructed the defences of the city in such a way — both on the landward side and to repel any attack from the sea — that there was no need for the defenders to busy

themselves with improvisations; instead they would have everything ready to hand, and could respond to any attack by the enemy with a counter-move. (8.5)

The Romans, by contrast, had failed to prepare completely, because they had left Archimedes out of their calculations: "Here they failed to reckon with the talents of Archimedes or to foresee that in some cases the genius of one man is far more effective than superiority in numbers. This lesson they now learned by experience" (8.5).

Bested by Archimedes' superior skill and planning, Marcellus could save face only by deploying the ancient Roman predecessor to the Italian art of *sprezzatura* (literally, "disdain," or making a serious matter seem effortless).[2] So he made a joke of his discomfiture. In the ancient world, puns were a sign of urbanity, and people committed them to memory rather than groaning at them. Polybius records the pun with admiration: "Marcellus' operations were thus completely frustrated by these inventions of Archimedes, and when he saw that the garrison not only repulsed his attacks with heavy losses but also laughed at his efforts, he took his defeat hard. At the same time he could not refrain from making a joke against himself when he said: 'Archimedes uses my ships to ladle sea-water into his wine-cups, but my *Sambuca* band have been whipped out of the wine-party as intruders!' So ended the efforts to capture Syracuse from the sea" (8.6).[3]

Ironically, Archimedes had set up this panoply of war machines to face another enemy, and another regime had assigned him the task. The man who had lured him away from pure mathematics to military engineering was Hieron II, the

talented general who had become ruler of Syracuse by popular acclaim in 264. A treaty with Rome in 263 BCE had confirmed Hieron's title as king over the southeastern corner of Sicily, while keeping the size of his realm under careful control; the rest of the island was administered as a Roman province. For the next forty-eight years, until his death in 215, Hieron loyally maintained his alliance with the Romans, transforming Syracuse into a cultural capital as well as a regional power. When the king invited his kinsman Archimedes to prepare the defenses of Syracuse, it was to protect the city from Carthage, not from Rome. But Hieron's death in 215 had abruptly overturned this prosperous situation. His immediate successor, his fifteen-year-old grandson Hieronymus, began making overtures to Carthage but ruled for only thirteen months before assassins killed him, his wife, and the rest of his family. The monarchy was replaced by a democratic government, but this, too, favored the Carthaginians rather than Rome. It was the sudden instability of Syracuse that prompted Marcellus to muster his attack in 214, forcing Archimedes to turn his bristling arsenal against the very people who had been the trusted allies of Syracuse for almost half a century.

But Archimedes really had no choice. He understood the realities of siege warfare in the ancient world. Conquered cities were torched and looted, and their inhabitants were treated brutally: many were raped, killed, or both, while the survivors were sold into slavery. Exceptionally large cities might be spared, as Athens had been spared by the Spartans in 406, but there was no guarantee that mercy would guide the victors' conduct. Economically, it was probably more practical to leave an exceptionally large city to prosper as a future trading part-

ner, but by the time a city fell to a siege in antiquity, the besiegers had usually been at work for years, and the hatreds on both sides were deeply ingrained. Like Archimedes, Polybius had experienced the realities of siegecraft personally. He was able to write so vividly about the siege of Syracuse because he had witnessed the Roman army's final conquest of Carthage in 146 BCE, a brutal house-to-house campaign that ended, at least according to ancient writers, with the leveling of the city and the sale of 50,000 survivors on the slave market. In fact, the leveling was not complete: the archaeological site on the outskirts of modern Tunis preserves extensive tracts of Carthaginian construction, just as the Nazi destruction of Warsaw, Poland, in 1944 left buildings standing but in ruins. The story that the Romans salted the earth after destroying Carthage is a nineteenth-century invention.[4] But the miseries of starvation and slavery were real fears when ancient cities came under attack.

Ancient military engineering, therefore, often became a life-or-death business on a cataclysmic scale, and it is not surprising that Archimedes' defense of Syracuse fit into a tradition of tales about how a single quick thinker could save a besieged city from disaster. The Roman architect Vitruvius, a onetime catapult maker for Julius Caesar, provides several examples of these engineer-saviors in the tenth of his *Ten Books on Architecture*, culminating in his account of a battle he must have seen himself: Caesar's siege of Marseille, which was thwarted by a last-minute stratagem on the part of the city's residents. Caesar's engineers, presumably including Vitruvius, had built an enormous wheeled siege tower, tall enough to allow his troops to climb up high enough to scale the city walls. In addition, each of its several levels bristled with banks of catapults to

pound away at masonry. Finally, a massive bronze-tipped battering ram protruded from the monster's front to smash down the strongest wooden gate. The night before the dreadful tower began to move toward its target, the people of Marseille crept out to dig a hasty moat between their city's walls and the gigantic machine, flooding the newly cut channel with water and any other liquid they could gather, from kitchen pots to chamber pots. When the Romans began their advance the following morning, they found a swamp rather than dry ground. As they dragged the siege tower forward, its wheels churned deep into the mud, stopping the deadly behemoth too far away to be of any use in scaling the walls of Marseille, but close enough for the defenders to whip out a version of Archimedes' "hand," grab the machine's great battering ram by its snout, and topple the whole tower onto its side. A rain of fire arrows and molten lead quickly finished it off. From this experience, Vitruvius concludes that "these victories by besieged cities were not achieved by machines; instead, they were liberated by the cleverness of architects pitted against various kinds of machines."[5] In fact, before telling these heroic tales of military engineering, he had warned his readers that the art of defense is always a matter of improvisation: "Defensive strategies, on the other hand, cannot be described in words, for attacking armies do not outfit their siege engines according to our descriptions; rather, their machines are most often upset by the clever swiftness of an extemporaneous strategy, carried out without machines."[6] What Archimedes achieved in Syracuse, Vitruvius would have argued, was a triumph of the mind rather than of mechanics.

Today, the only physical remnant of Archimedes' legendary defense system is the Euryalus fort on the heights of Epipolae

(Plate 17). The surrounding neighborhood is called Belvedere (Italian for "beautiful view"), and the view is indeed spectacular —although the northern stretches of the Syracusan coast, up to the once glorious port of Augusta, have been marred since the 1950s by oil refineries, and Belvedere itself has been developed in ugly modern apartment blocks. The original fortress was built by Dionysius I between 402 and 397, in the wake of the Sicilian expedition, and was part of a system of city walls that extended for twenty-seven kilometers. Later rulers, including the tyrant Agathocles (ruled 317–289) and Hieron II (with the help of Archimedes), added to the original fort, whose impressive ruins we can see today. The stronghold, now called Castello Eurialo (Euryalus Castle) sits, naturally enough, at the most vulnerable part of the highland, where level ground would have provided relatively easy access from the massif to the city below. As Polybius says, steep crags make other potential paths from Epipolae to the seashore virtually impossible to negotiate, especially for an army. Today, the road leading into Syracuse from Catania, the site of the nearest airport, still passes directly beneath the Euryalus Castle, with concrete bunkers from World War II poking their heads out of the pocked, porous limestone, although they are camouflaged to look like their surroundings. The limestone itself is both natural and worked by human hands; the carving of wind, rain, and earthquake is sometimes hard to distinguish from the carving of tools. But there is no mistaking the human ingenuity that went into creating the fortress itself. Potential invaders hoping to attack Syracuse from the northern heights faced three successive rings of moats, with an extra fortification wall erected between the second and third moats. Remnants of the colossal supports

for the drawbridge that crossed the third moat still survive, as does a maze of well-preserved tunnels connecting the third moat with different areas of the fortress and the exterior. The fortress keep is a trapezoidal structure with five towers (still visible), its entrance defended by a pincer gate (a gate reached by a progressively narrowing corridor enclosed between high walls). And anyone who finally gained entrance to this bastion would find that Ortygia was still seven kilometers distant, protected by its own set of fortifications. With catapults and "hands" in place, it is no wonder that Marcellus decided to give up a frontal attack on Syracuse altogether.

The city finally fell to the Romans in the same way that impregnable defenses were usually defeated in the ancient world: by treachery. The pro-Roman faction among the Syracusans, still loyal to the policies of Hieron, simply opened the gate one day in 212 and admitted Marcellus and his troops in hopes of leniency. Considering what might have happened, the Roman terms were relatively generous. Marcellus allowed his soldiers to loot to their hearts' content, but not to burn the city or kill its inhabitants. In particular, he ordered them to spare Archimedes. But sparing the great strategist meant recognizing him in the first place. The Roman soldier who came upon the old man found him drawing a mathematical diagram in the sand and asked who he was. "Let me finish my diagram," Archimedes replied, and for that perceived insolence the soldier struck him dead.

The story of Archimedes' death, which became as famous as his adventure with the bath (discussed below), shows symbolically how much Rome still had to learn from Greece. The ancient authors who tell us the story all write from the Roman

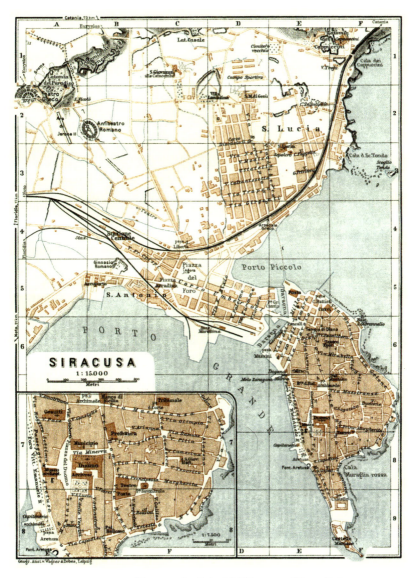

PLATE 1 Map of Syracuse by Heinrich Wagner and Ernst Debes,
Leipzig Geographical Institute, 1929. Courtesy of the 1900 Map Collection,
www.discusmedia.com.

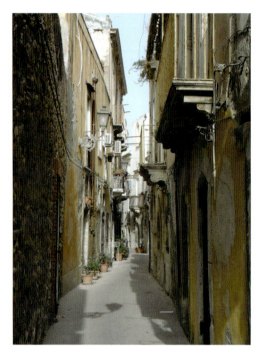

PLATE 2
Street in Ortygia,
Syracuse.
Author's photo.

PLATE 3
Hellenistic houses
in Syracuse.
Author's photo.

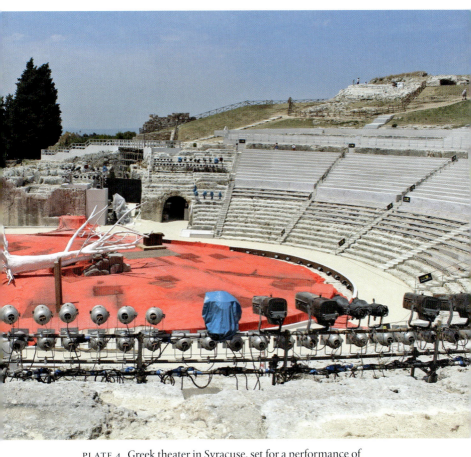

PLATE 4 Greek theater in Syracuse, set for a performance of
Euripides' *Phoenician Women* in 2017. Author's photo.

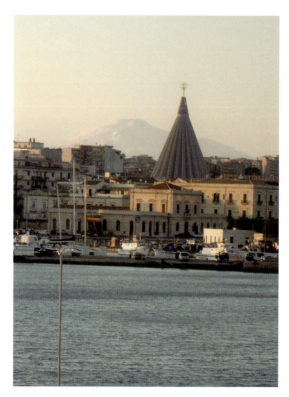

PLATE 5
The Sanctuary of
the Madonna delle
Lacrime in Syracuse,
with Mount Etna in
the distance.
Author's photo.

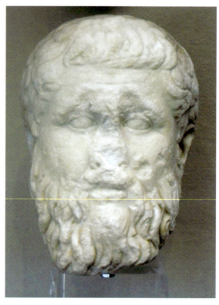

PLATE 6
Head of Plato from
the Museo Regionale Ar-
chaeologico Paolo Orsi,
in Syracuse.
Author's photo.

PLATE 7
Red-figure Athenian *lekythos*
(oil jar) with a herm and
an altar, circa 480–70 BCE.
Museum of Fine Arts,
Boston, MA.
Bridgeman Images.

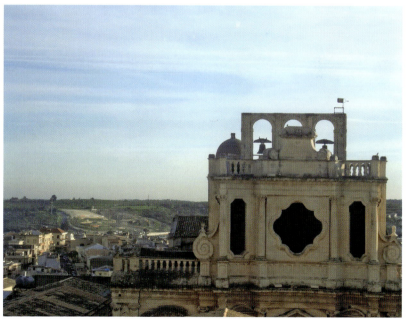

PLATE 8 The Assinarus River bed, as seen behind the church of
San Carlo al Corso, Noto. Author's photo.

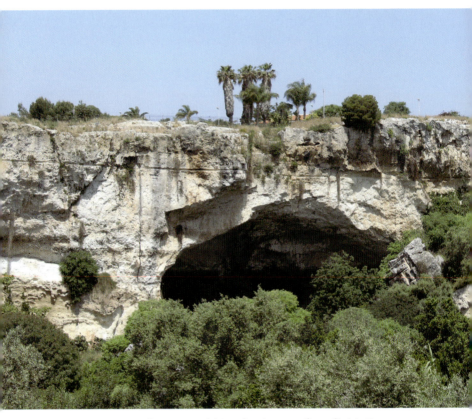

PLATE 9 The Latomia del Paradiso (quarry of paradise) in Syracuse.
Author's photo.

PLATE 10
Valencia oranges in the
Latomia del Paradiso.
Author's photo.

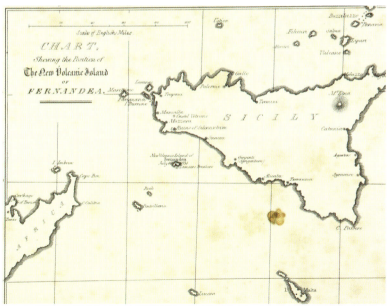

PLATE 11 William Henry Smyth, map of Sicily and Malta from 1832, including
the volcanic island of Ferdinandea. Wikimedia Commons.

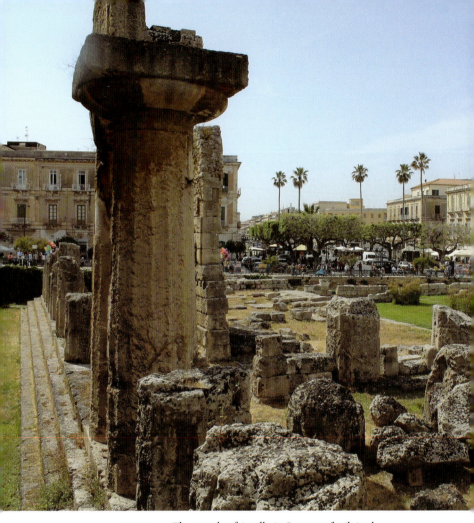

PLATE 12 The temple of Apollo in Syracuse (built in the sixth century BCE). Author's photo.

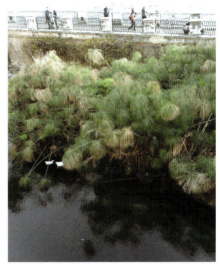

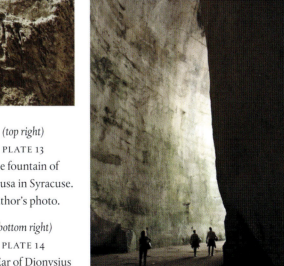

(top right)
PLATE 13
The fountain of
Arethusa in Syracuse.
Author's photo.

(bottom right)
PLATE 14
The Ear of Dionysius
in Syracuse.
Author's photo.

PLATE 15 Emerging from the Ear of Dionysius. Author's photo.

PLATE 16 Plato's Academy in Athens. Author's photo.

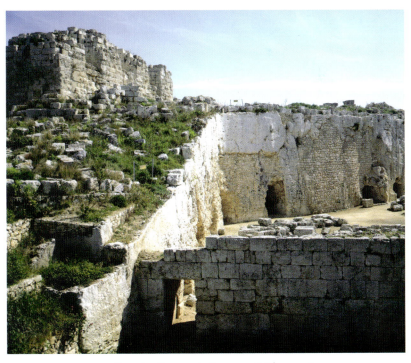

PLATE 17 Euryalus Fortress in Syracuse. Bridgeman Images.

PLATE 18 Athanasius Kircher, Archimedes' burning mirror, from Athanasius Kircher, *Ars magna lucis et umbrae* (Rome: Ludovico Grignani, 1646). Bridgeman Images.

PLATE 19

Bust of Archimedes from Giuseppe Torelli, *Archimedis quae supersunt Omnia* (Verona: Torelli, 1792). Wikimedia Commons, accessed 16 October 2017, https:// commons.wikimedia.org/wiki/ File:Archimedes_Bust.jpg.

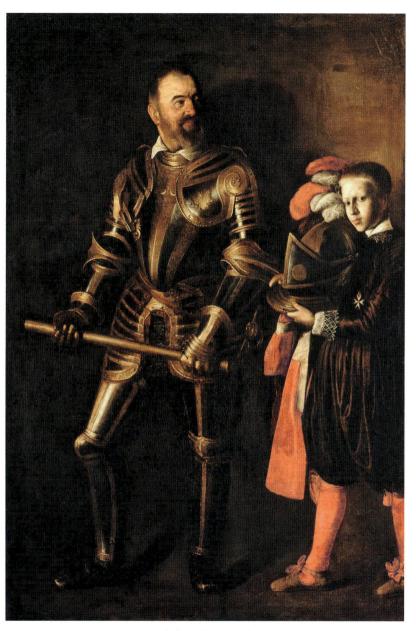

PLATE 20 Michelangelo Merisi da Caravaggio,
Portrait of Grand Master Alof de Wignacourt and a Page, 1608.
Paris, the Louvre. Wikimedia Commons.

PLATE 21
Entrance to
Fort Sant'Angelo,
Birgu, Malta.
Author's photo.

PLATE 22
Lorenzo Corbé sings
in the Ear of Dionysius.
Author's photo.

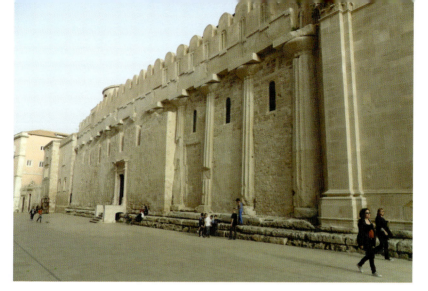

PLATE 23 Columns of the ancient temple of Athena, now part of the Cathedral of the Nativity of the Blessed Virgin, Syracuse. Author's photo.

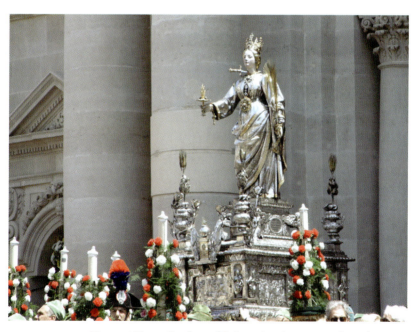

PLATE 24 Giovanni Rizzo, *Simulacro* of St. Lucy (1599), emerging from the Cathedral of the Nativity of the Blessed Virgin, Syracuse, 9 December, 2016. Photo Salvo Cannizzaro. Wikimedia Commons, accessed July 2018, https://commons .wikimedia.org/wiki/File:Simulacro_di_S.Lucia_(Santa_Lucia_delle_quaglie)_-_pan-oramico.jpg.

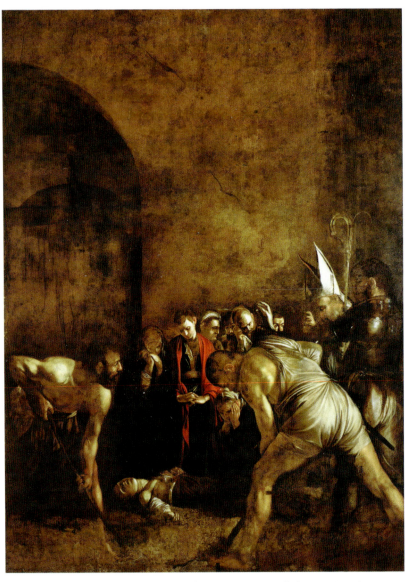

PLATE 25 Michelangelo Merisi da Caravaggio, *Burial of St. Lucy* (1608), Santa Lucia alla Badia, in Syracuse (formerly in Santa Lucia al Sepolcro). Wikimedia Commons, accessed 18 October 2017, https://commons.wikimedia.org/wiki/File:Burial_of_Saint_Lucy-Caravaggio_(1608).jpg.

point of view, according to which Marcellus, the general who brought Sicily definitively under Rome's control, by definition had to be portrayed as a hero. It was not a simple assignment: Marcellus had captured Syracuse on fairly clement terms, but he had also been outsmarted by Archimedes and then failed to preserve the mathematician's life, despite the fact that Archimedes would have been far more help to Rome alive than dead (just as Wernher von Braun, the Nazi rocket scientist, would prove useful to the US space program after World War II). At least Marcellus had the wit and the culture to make a joke about his inability to take Syracuse by force. He is also said, perhaps predictably, to have wept at the news of Archimedes' murder and to have executed the sword-happy soldier who had failed to recognize the signs of eccentric genius in the little old man who sat drawing diagrams in the sand.[7]

Two centuries later, Vitruvius, a Roman civilized by a Greek education, would never have made the same mistake as that slow-witted, fast-angering Roman soldier. Despite his fellow feeling for Archimedes as a military engineer, Vitruvius understood that his idol was, above all, a mathematician. He says as much in the preface to the ninth of his *Ten Books on Architecture*, which he devoted to astronomy and sundials. The discussion begins with Vitruvius deploring, in strikingly modern terms, the amount of money and attention that his contemporaries lavish on athletes, after which he provides an alternative list of people who truly deserve such adulation. He begins with Plato, praising him not for his insights into the nature of knowledge and the human soul, but because he solved a practical mathematical problem: how to double the area of a square plot of land. That process involves what we call irrational numbers,

and Vitruvius (perhaps the first writer to address the subject in Latin) calls them, somewhat clumsily, "numbers that cannot be found by multiplication, but are discovered by drawing a succession of lines."[8] Next he moves on to Pythagoras, who discovered how to make a carpenter's square with a true right angle—by using, of course, the Pythagorean theorem. And then there is Archimedes. "In his limitless wisdom," Vitruvius begins, "he discovered many wonderful things," and the awestruck Roman architect is tempted to write about them all. For this brief preface, however, he chooses the anecdote that ends with Archimedes running wet and naked through the streets of Syracuse shouting "Eureka, eureka!" ("I've found the answer! I've found it!")[9] A body displaces its weight in water; this, the concept of specific gravity, is what Archimedes discovered as he lowered himself into his tub. "So what benefit is there in the fact that Milo of Croton was undefeated as a wrestler?" Vitruvius asks rhetorically, before suggesting that mathematicians and engineers should be awarded more than an athlete's palms and garlands—instead, he suggests, they should have triumphal parades just like the greatest generals, or divine honors, with their images set in temples among the statues of the gods.[10] (Ironically, in singling out Milo of Croton among all the athletes of antiquity, he was referring to Pythagoras' son-in-law.)

Perhaps Vitruvius knew that two ancient engineers eventually did become divinities: the Egyptians Imhotep and Amenhotep son of Hapu, both of whom were venerated in Memphis in his own time.[11] As he confesses, he hoped to attain a kind of immortality through his *Ten Books*, the only comprehensive architectural treatise to survive from antiquity, and probably the first to be written. Archimedes stands somewhere in between:

a figure of legend, but also an author who speaks for himself in his own witty texts as well as living on in the praise of ancient writers, the traces of his improvements to the city defenses of Syracuse, and the machines he invented. Some of these machines probably never existed; they are part of the legends that arose around their inventor. Some have become obsolete over the course of the millennia. But some of those machines are still in use today, more than two thousand years after Archimedes lived, like the water screw that still bears his name.

This preface by Vitruvius reminds us why using ancient sources always requires taking the author's own biases into account. Plato would have been appalled at the Roman architect's reason for including him on the list of famous mathematicians. In Plutarch's dialogue *Quaestiones convivales* (Table talk), one of the diners reminds the other guests that the great Athenian "disapproved of those who ... tried to reduce the doubling of a cube to a series of mechanical moves, as if they could seek to find a ratio by irrational means—this is how they destroy everything that is good about geometry, letting it drop back into the sensible world, rather than lifting it up and participating in the eternal, bodiless Forms where God is and always shall be."[12]

Pythagoras, too, was almost certainly more interested in his theorem's interplay of number and line than in its practical applications for making the perfect carpenter's square. And like these two, Archimedes preferred theoretical mathematics, occasionally using his insights to solve practical problems with astonishing panache. In one of his own treatises, the *Sand-Reckoner*, he states that his father, Phidias, was an astronomer in Syracuse, and we have seen above, ancient sources report that Archimedes was related to his longtime patron Hieron II.[13]

Today, we know far more about this remarkable natural philos-opher's ideas and inventions than we do about the man himself, except for the fierce powers of concentration that drove him naked through the streets of Syracuse shouting "eureka" and inspired his impatient retort to the Roman soldier who took his life. In her delightful book on *Archimedes in the Roman Imag-ination*, Mary Jaeger provides a vivid rundown of the sources we have for creating a biography of the mathematician whose modern colleagues rank him, together with Isaac Newton and Karl Friedrich Gauss, as the greatest of all time: "histories [in-cluding, as we have seen, that by Polybius], speeches, an epic poem, philosophical dialogues, collections of moral examples, a treatise on architecture [that is, by Vitruvius], a compendium of table talk, a poem on weights, and a biography written about someone else."[14]

There is one more source to consider: Archimedes' own works. These were originally preserved, like all ancient Greek texts, in carbon-based ink on scrolls of papyrus. Syracuse is the only place in Europe where the papyrus plant grows naturally, but transforming its stalks into a smooth writing surface is a laborious process that the Egyptians had already turned into a major industry a thousand years before Archimedes was born. Tempting as it is to think of Hieron II fostering a local papy-rus trade, as some scholars have suggested recently, we have no definite record of anyone writing on Syracusan papyrus before 1674.[15]

When ancient authors refer to "books," like the *Ten Books on Architecture* by Vitruvius, they really mean papyrus scrolls, each of which normally contains about as much text as a mod-ern book's chapter. Before committing their thoughts to papy-

rus, however, ancient writers often sketched out ideas with a pointed stylus on wooden tablets covered with a thin layer of wax. The wax could be scraped smooth and reused, and eventually replaced by a fresh layer. Wax tablets, then, were cheap, temporary slates on which ancient writers could change their wording and refine their thoughts. But not even a wax tablet could keep up with Archimedes' racing thoughts. He was so full of ideas that he would write on virtually anything, sometimes tracing diagrams in the sand or the ashes of his hearth, or even on his own belly when his students rubbed him down with oil after his bath.[16] Transferring his work to the semi-permanent and expensive medium of papyrus would have come at a later stage.

Between the fourth and fifth centuries CE, a new kind of book emerged in the Mediterranean world: the parchment codex, written on stretched animal skins (the best grade, vellum, was made of lambskin). Far more durable than papyrus, a single parchment volume could also hold the contents of a dozen papyrus scrolls. These were books as we understand them.

The texts of Archimedes that survive to us complete from antiquity are the ones that were transferred to parchment, and of these the most exciting to contemporary scholars is a relatively new discovery: a palimpsest (a recycled manuscript) that was first spotted in Constantinople in 1899. A French collector acquired it in 1908, and then it was either stolen or temporarily lost until it showed up in 1998 at an auction at Christie's in New York. Fortunately, the manuscript's buyer has loaned it to the Walters Art Museum in Baltimore, Maryland, and the book is available for scholarly study.[17] Vellum is so durable that a text written in ink can simply be scraped off and replaced, which is

what happened to the Archimedes palimpsest in the thirteenth century: a pious Byzantine scribe decided to turn a collection of ancient Greek works on mathematics, including seven treatises by Archimedes, into a book of Christian prayers. Traces of the original texts are still visible beneath the thirteenth-century script, but they can be made much more legible by reading them under ultraviolet light, and especially by using digital imaging to enhance the contrast between the faint traces of the original letters and the underlying page. Most exciting of all, the Archimedes palimpsest includes works missing from the other surviving manuscripts.[18]

As ancient authors already knew, Archimedes was a writer of remarkable scope. At some point, he clearly studied at the Museum and Library of Alexandria before returning to Syracuse, and he corresponded with its director, Eratosthenes of Cyrene (the mathematician who calculated the size of the earth). Using geometry rather than algebraic formulas (which had not yet been invented), he calculated the value of pi, found ways to determine the center of gravity of various shapes, measured the areas of circles and spirals by resorting to infinitesimals (a precursor to calculus), determined the size and spherical shape of the earth from the behavior of floating bodies, calculated the areas of parabolas, reckoned the number of grains of sand to be found in the universe, and addressed a poetical story problem to Eratosthenes that has such a preposterous solution that the whole enterprise may be a learned joke between two of the greatest scientific minds of antiquity.[19] The story that Vitruvius tells us about Archimedes running naked through the streets of Syracuse shouting "eureka" begins when Hieron asks his learned friend to determine whether his golden crown is really

made of gold. Hieron suspects that he has been cheated by the goldsmith (applying a bit of clever psychology to the problem). After lowering himself into the bath, Archimedes realizes that different metals have different specific weights, and by sinking Hieron's crown in water with an equal amount of pure gold he is able to detect the fraud. In Archimedes' written legacy, what we have is not a naked run through Syracuse, but rather a sober treatise on floating bodies, which in turn would inspire Galileo's researches on the same topic in the seventeenth century.[20] The distracted intellectual of the Vitruvian portrait appears in his own writings as a sophisticated wit.[21]

If the ancient Romans marveled at Archimedes' war machines and modern scholars marvel at his writings, the ancient Alexandrians marveled at another of the inventions that combined Archimedes' theoretical expertise with an ingenious solution of several practical problems at once. This was a gigantic cargo ship, called the *Syracosia* (the Syracusan), designed to transport grain across the Mediterranean. One ancient writer, Moschion, devoted an entire papyrus scroll to describing the vessel, but we have only a paraphrase of that work in the amusing book of anecdotes titled *Deipnosophistae* (The philosophers at dinner), compiled by the writer Athenaeus in the late second century CE.

Rather than the standard five banks of oars, the *Syracosia* had twenty, with three masts to serve its exceptional length of 360 Roman feet (about 104 meters). The floors were decorated with mosaics, and the cabins were furnished with couches. Paintings and statues ornamented the cabins and decks. The upper deck also boasted a gymnasium and gardens with potted plants, tents, a temple to Aphrodite made of cypress wood

with an agate floor, a library, a clock, a bath with hot water, twenty stalls for horses, and a fish tank. The bilge was emptied, of course, by a set of Archimedes' famous spiral pumps, and just in case the ship should run into pirates, it carried defensive towers and catapults that threw both stone shot and metal bolts. The crew numbered six hundred, so the ship also had its own law court.[22]

There was only one problem with the *Syracosia*. It was so big that only two harbors in the Mediterranean were wide and deep enough for it to dock successfully: the Great Harbor of Syracuse, and the harbor of Alexandria (another capacious port, the Great Harbor of Malta, was unimportant in the third century BCE). Hieron found a graceful solution to the problem by giving the ship and its cargo as a gift to Ptolemy III Euergetes (Benefactor) of Egypt, who desperately needed the grain to compensate for a crop shortage in his own country. The majestic vessel made a single voyage. Once its bounteous cargo of grain, wool, and Sicilian salt fish had been unloaded in Alexandria, Ptolemy promptly hauled the *Syracosia* ashore and turned it into a tourist attraction, first taking patriotic care to rename it the *Alexandrian*.

Early modern Europeans were fascinated by yet another project they confidently ascribed to Archimedes: the "burning mirror," a gigantic parabolic reflector mounted on land that could focus a beam of sunlight on a ship at sea and set it afire—as was allegedly done during Marcellus's siege of Syracuse (Plate 18). The story, however, does not appear until the Byranzine era. For early modern writers like the seventeenth-century Jesuit Athanasius Kircher, one of the most enthusiastic researchers into the subject, this detail did not seem particu-

larly important: ancient and Byzantine texts were all old, and in any case all of the ancient texts available to him were preserved in manuscripts of Byzantine date. Some ancient authors (though not Polybius) did report that Archimedes' machines had thrown fire at the Roman ships, but this "fire" consisted of flaming matter—pitch, for example—not pure, unsullied light.[23] Byzantine writers began to suggest that the trick had been done with mirrors rather than "Greek fire," well aware that the Pharos (the great lighthouse of Alexandria) had been constructed circa 250 BCE, during Archimedes' lifetime, with a large bronze mirror at the summit.[24] In Archimedes' century, the seven wonders of the world become a popular subject for lists (Archimedes also must have heard about the collapse of the Colossus of Rhodes in 226), and new developments in early modern technology and natural philosophy led to a similar revival of interest in these ancient wonders during the seventeenth century, as well as in Archimedes himself (Plate 19).[25]

But if Kircher did not distinguish as strictly between ancient and Byzantine sources as a modern classicist would, he was ruthless in his devotion to experimental method. A German Jesuit who spent most of his life in Rome, he took advantage of a stop in Syracuse in 1636 en route to Malta to measure the harbor with his own instruments. This led him to conclude that Marcellus and the Roman fleet could have come much closer to land than the 300 paces (roughly 300 meters) reported by the Byzantine writer John Tzetzes, and hence that Archimedes could have mounted functional mirrors on the sea walls, but not mirrors capable of burning ships at a distance on the open sea.[26] Kircher had experimented with projecting light with parabolic mirrors at the Jesuit College in Rome (he called the

activity *actinobolismus* (ray throwing), and he could assert that Archimedes might have been able to burn a ship at a distance of 30 paces, but no more than that.[27] However, none of these sober considerations kept Kircher from including a lavish engraving of the burning mirror in his *Ars magna lucis et umbrae* (Great art of light and shadow) of 1646 and including his discussion in a chapter titled "Magia catoptrica" (mirror magic). He was as expert at marketing as he was at mathematics. In many ways, he and Archimedes were kindred souls.

Light is beautiful to look upon; for, as
Ambrose says, it is the nature of light that all
grace is in its appearance. Light also radiates without
being soiled; no matter how unclean may be the places
where its beams penetrate, it is still clean. It goes in
straight lines, without curvature, and traverses the
greatest distances without losing its speed.

JACOBUS DE VORAGINE,
Golden Legend

4

CARAVAGGIO *in* SYRACUSE

When he arrived in Syracuse in 1608, Michelangelo
Merisi da Caravaggio, the "outstanding painter in
Rome," had become a notorious fugitive from two
different cities and two different countries.[1] In May 1606, he
had killed a Roman thug, Ranuccio Tomassoni, in a scuffle
on a tennis court. The penalty for murder was death or ban-
ishment. Rather than wait to be arrested, Caravaggio ran for

shelter to the person who had protected him ever since his boyhood in Milan: Costanza Sforza Colonna, a Roman noblewoman whose Milanese husband had employed the painter's father, Fermo Merisi, as an architect and household administrator.[2] Fermo had died of the plague in 1577, and his wife Lucia had died in 1584. Thus, Caravaggio was an orphan when, at thirteen, he signed on as an apprentice to the Milanese painter Simone Peterzano.[3] For the rest of Caravaggio's life, Colonna would keep a watchful, almost motherly, eye on her talented young protégé, as he finished his apprenticeship, moved from Milan to Rome, and began to win prestigious commissions in her native city. She moved constantly between Milan, Rome, and Naples; her marriage was not a happy one, despite the fact that she eventually bore her husband seven children.[4]

Caravaggio's paintings would always reserve a special place for elderly women (although Colonna was only sixteen years older than the artist). Like the chorus in an ancient Greek drama, they react to a scene as we might, but in a quiet, unobtrusive way—recognizing Christ as a guest at the *Supper at Emmaus* long before his disciples do, watching over the crucified St. Andrew as he dies with a vision of heaven before him, kneeling before the infant Jesus to receive his blessing with a look of pure rapture. Elderly women are often the brunt of insults and derision in early modern art and literature, but in Caravaggio's work they are almost always sensitively portrayed as images of compassion. The exception is the fierce old servant who watches the Jewish heroine Judith sever the head of the Assyrian general Holofernes, ready to catch their prize in a sheet. Colonna was Caravaggio's personal face of compassion whenever he needed it most, and he needed it desperately in 1606.

He ran from the tennis court near Piazza Navona to her feudal lands south of Rome, where he could shelter in safety from the *sbirri* (the pontifical police). For better or worse, her family had made its own laws in that region for centuries.[5] Her castle walls also shielded Caravaggio from Tomassoni's henchmen.

Nonetheless, his patroness encouraged the painter to move still further south, to Naples—where Colonna also had vast land holdings, a city palazzo, and a suburban villa, the spectacular (and still extant) Villa Cellamare. After spending a few months in Naples creating a series of huge, glorious canvases, Caravaggio had sailed to Malta in July 1607. He made the trip on a galley that belonged to the Knights Hospitallers of St. John (the Knights of Malta) and was commanded by Fra' Fabrizio Sforza Colonna, the third and youngest of Costanza Sforza Colonna's sons. This suggests that her resourceful influence had played a role once again, but the invitation itself may well have come from none other than the knights' grand master, Alof de Wignacourt.[6] Caravaggio's troubled fortunes at last seemed to be improving.

The Knights of St. John had begun as an order of lay brothers who ran a hospital for pilgrims in the Christian Kingdom of Jerusalem in the eleventh century, at the height of the Crusades. Recognized as a religious order in 1133, the brothers became increasingly militant as the Kingdom of Jerusalem lost its grip on the Holy Land. Eventually the order became, somewhat schizophrenically, a group of celibate knights who fought fiercely in defense of Christianity but at the same time ministered to the patients in their hospitals without any consideration of faith, nationality, or social status. Expelled from the Holy Land in 1291, they moved to Rhodes, where they were known as the

Knights of Rhodes until their expulsion from the island by the
Ottoman Turks in 1522. After eight years of exile in Italy, they
took possession of Malta in 1530. In 1565, a few hundred knights
and several thousand Maltese held off a four-month siege by
the Ottoman sultan, Süleyman the Magnificent. This victory
—followed by the naval victory at Lepanto in 1571—divided
the Mediterranean world into stable Ottoman and European
spheres of influence, in spite of constant pirate raids and ex-
changes of captives on both sides. Malta's position at the cen-
ter of the Mediterranean and its deep, sheltered harbor gave the
tiny archipelago a strategic importance far beyond its size. The
Knights of St. John drew their members from a wide range of
European noble families, and joining the order had become es-
pecially popular after heroic stories of the siege and the victory
at Lepanto had time to spread. Wignacourt was a charismatic
figure, a fierce warrior who did humble service, like all his
brethren, in the order's Sacred Infirmary. This was quite pos-
sibly the best hospital in the world, drawing on both European
and Levantine medical traditions, where every patient, from
Christian knight to Ottoman slave, had an individual bed and
was fed from silver dishes, and all were treated as Christ him-
self would have been.

As one of the best-known painters in Italy, Caravaggio fit
perfectly into Wignacourt's plans to transform the Maltese
capital, Valletta, into a city of European stature, and the knights
into something more than a band of exceptionally tough fight-
ers for the Christian cause.

Valletta was an entirely new settlement, laid out in a grid
plan on a limestone plateau that looks eastward over one of the
world's greatest natural harbors (as well as another magnificent

harbor on the western side). In 1566, Grand Master Jean Parisot de Valette had placed the cornerstone of the city that bears his name, but its ambitious structures, including the Grand Master's Palace, the Church of St. John (the spiritual center of the order), and the eight auberges, or residences for the knights, as well as the city's massive ring of fortifications, had taken nearly forty years to build.[7] In 1610, Wignacourt would begin work on an aqueduct to bring water to Valletta, which is among the reasons he is one of the rare grand masters to have been popular with the Maltese people as well as the knights.

Wignacourt also enhanced the ceremonial aspects of his office, increasing the number of his attending pages from six to twelve, and commissioning at least two new sets of elaborate dress armor (one of them on display in the armory of the Grand Master's Palace). Both improvements feature prominently in his full-length portrait by Caravaggio, painted shortly after the painter's arrival in Malta.

Caravaggio shows Wignacourt as a vigorous sixty-year-old, with a trim physique and an alert air, holding the baton of office (which resembles a royal scepter) as he looks intently off into the distance, his thoughts riveted on something far away and over the heads of his viewers, the large wen to the left of his nose conveniently buried in shadow (Plate 20). Every inch of his steel armor has been incised with an elaborate brocade design, highlighted by elements plated in gold. A rapier with a gold-plated basket handle hangs at the grand master's left hip. He is every bit as grand as his title.

No suit of dress armor would be complete without its helmet, but rather than have the grand master wear his massive close helmet with its red and white plumes, Caravaggio shows it

being carried by a page, together with a red twill banner embroidered with the Wignacourt coat of arms: a white cross on a red background. The blond page, with his close-cropped bowl haircut, is dressed in the height of fashion, with an enameled white, eight-pointed Maltese cross pinned to his velvet jerkin and his hose dyed an expensive cardinal red. His billowing trousers are stylish long slops, and his linen collar and cuffs are edged with the latest in luxury ornament: a profusion of French needle lace. The boy, whose forthright gaze immediately engages our attention, may be Nicolas de Paris Boissy, who would be elected grand prior of France fifty years after the painting of this portrait: the long nose; broad forehead; wide-spaced eyes; narrow, prominent chin; and intent gaze all reappear, along with the pensive expression, in an engraving of Boissy as grand prieure.[8]

Caravaggio also painted a seated portrait of Wignacourt. Now lost, it may have inspired the portrait by Giulio Cassarino that hangs in the Wignacourt Museum in Rabat, Malta.[9] For these efforts, the grand master awarded Caravaggio the prestigious Cross of Malta.[10]

While he burnished his own image as a head of state, Wignacourt took some equally imaginative steps toward refining the order he headed. Traditionally, the Knights of St. John had placed an inordinate emphasis on lineage: in Caravaggio's time, Italian Knights of Justice, those of the highest rank, were required to prove exclusively noble descent (that is, ancestors with coats of arms) going back two hundred years. Illegitimate sons were out of the question, as were commoners. Yet for all their quarters of nobility and professions of chivalry, in many respects the Knights of St. John were a rough-and-tumble lot of Catholic pirates.[11] Pope Paul V had already written Wignacourt

in 1606 to complain about their worldliness, declaring that virtuous conduct was far more important than ancestry to their mission in the world.[12]

In December 1607, Wignacourt began a campaign to admit Caravaggio to the order on precisely the terms called for by the pope, telling the order's ambassador to the Holy See, Francesco Lomellini, of his eagerness to honor "a most virtuous person, of most honored qualities and habits and whom we keep as our particular servant, and whom, in order not to lose him, we wish to console by giving him the habit of the Grand Master."[13] Wignacourt did admit that the "most virtuous person" had killed another man, but "in a brawl"—not a duel, which would have been a far more serious offense.

In February 1608, the grand master petitioned the pope in person to express his wish "to honor some persons who have shown virtue and merit and have a desire and devotion to this service and that of the Hospital," asking for "one time only" to award the habit of magistral knight to "two persons favored by him and to be nominated by him."[14] The other candidate was probably the comte de Brie, whose illegitimate birth turned out to offend the knights far more than Caravaggio's conviction for murder. In any case, the pope granted both dispensations. Wignacourt had already given Caravaggio two slaves as attendants, presumably former subjects of the vast Ottoman Empire who had been captured on one of the knights' corsair raids and who might well be waiting for relatives to pay their ransom. In keeping with his stature, the grand master had two hundred slaves of his own.

Caravaggio's chief claim to the "virtue" Wignacourt ascribed to him was, of course, his skill as a painter, but among

the knights his prickly sense of personal honor also distinguished him as a gentleman. Within his intensely hierarchical society, Caravaggio had always clung fiercely to the lower rungs of the aristocracy, perpetually ready to defend his position with sword, dagger, and poison pen. But his induction into the order as a "knight of magistral obedience" marked an important ratification of his status, not only in his own personal life, but also as part of the vision that both the grand master and the pope were developing for the order. Rather than enhance the knights' reputation as seafaring raiders, Wignacourt and Pope Paul V hoped to encourage a more contemporary idea of manly virtue and a broader interpretation of knightly service. These reinterpreted values would, in fact, eventually supplant the old Crusader ideal and become the governing vision of the contemporary order, which runs hospitals worldwide and includes women as well as men.

The bull of reception that recorded Caravaggio's entry into the Knights of St. John speaks eloquently for an aristocracy of achievement rather than birth: "Whereas it behooves the leaders and rulers of commonweals to prove their benevolence by advancing men, not only on account of their noble birth but also on account of their art and science, whatever that may be. . . . And whereas the Honorable Michael Angelo . . . having landed in this city and burning with zeal for the Order, has recently communicated his wish to be adorned with the habit and insignia of our Knightly Order, Therefore we wish to gratify the desire of this excellent painter, so that our Island Malta and our Order may at last glory in this adopted disciple and citizen with no less pride than the island of Kos (also within our jurisdiction) extols her Apelles."[15]

Apelles figured in ancient literature as the greatest painter of all time, both supremely skillful and learned enough to publish his treatises on art.[16] Caravaggio could not have hoped for higher praise as he entered the order. The solemn induction ceremony began with an overnight vigil in the oratory, the newly completed novices' chapel within the knights' great limestone Church of St. John, the massive, austere center point of Valletta.[17]

As he knelt in prayer, Caravaggio could not have avoided contemplating the back wall of the chapel, where what would be the largest work of his career—the dramatic, monumental *Beheading of St. John the Baptist*—was still in progress. The splendid altarpiece, scheduled to be officially inaugurated on August 29, the feast day of the Baptist's beheading, would substitute for the *passaggio*, the substantial sum of money that most Knights offered as an entrance fee into the order. For the only time in his life Caravaggio signed his work—in the red paint that he had used immediately before to depict the saint's spilled blood.[18] Appropriately, he included the new title that marks him as a devotee of the Baptist (Fra, or brother), signing the painting "F. Michelangelo." (The last few letters of his name are no longer visible; they flaked off at some point as the great canvas began to sag under its own weight.)

But as it turned out, Caravaggio missed the inauguration. He was either waiting to be arrested or already imprisoned on the other side of Malta's Grand Harbor, cooling his heels in the drunk tank of the prison of Sant'Angelo—ironically, the fortress that guarded the old capital of Vittoriosa and served as the island's jail was named after his patron saint, the Archangel (Sant'Angelo) Michael. On the night of August 18, a group

of six brawling knights, all Italian, had broken down the door of a seventh, Fra' Prospero Coppini, the organist for the Church of St. John. In the scuffle one of the group, Fra' Giovanni Rodomonte Roero, Conte della Vezza di Asti, had been wounded. Because the order's statutes expressly forbade the knights to engage in fights "with bloodshed" among themselves, the Italians were suddenly in deep trouble.[19] At first only two of the participants could be identified: Deacon Giovanni Pietro de Ponte, who had shot Roero with a most unchivalric *sclopo ad rotas* (wheel-lock pistol), rather than skewering him like a gentleman, and "Michael Angelo"—Caravaggio. The criminal commission that pressed charges on August 27 (and presumably saw to the arrest of both de Ponte and "Michael Angelo" immediately afterward) included every one of Caravaggio's recent patrons in Malta: Grand Master Wignacourt, whose portrait by Caravaggio hangs in the Louvre; Fra' Antonio Martelli, prior of Messina and the subject of a beautiful portrait in the Galleria Palatina in Florence; Fra' Ippolito Malaspina, grand bailiff of Naples, whom Caravaggio had portrayed as St. Jerome in a painting still preserved in Valletta; and Fra' Fabrizio Sforza Colonna, who had transported Caravaggio from Naples to Malta. Fra' Francesco de Antella—Wignacourt's secretary, for whom Caravaggio had just painted a *Sleeping Cupid*—was present as a nonvoting member of the commission (which also included another voting member unconnected with a painting by Caravaggio). On November 27, after a full investigation, the commissioners exonerated the organist, Coppini, and sentenced four of the other knights to prison. De Ponte, the gunman, was in a more serious position. He had violated the statutes of the order, an action that automatically condemned him to defrock-

ing and expulsion from its ranks.[20] On December 1, 1608, in a meeting of the Public Assembly of the Knights of St. John, de Ponte was ceremonially stripped, piece by piece, of his knightly regalia before hearing the formula that pronounced him "expelled and thrust forth like a rotten and fetid limb."[21] On the same occasion, Caravaggio was subjected to the same ritual humiliation, but in absentia and for different reasons. On October 6, he had escaped from prison and decamped to Sicily. Leaving Malta without the express permission of the grand master was another violation of the statutes, an act of lèse-majesté against the grand master that was punishable by defrocking and expulsion from the order. The ceremony that stripped Caravaggio of his knighthood took place, like his induction, in the oratory, beneath his picture of the *Beheading of St. John the Baptist*.[22]

Caravaggio's escape from prison could not have happened without help. Like the bastions of Syracuse, bristling with Archimedes' war machines, the fortifications of Malta were designed to be absolutely impregnable, and so they have proven to be—and not only in the era of the knights, but also in the age of modern weaponry. They survived an astonishing 3,343 bombing raids by the German Luftwaffe between 1940 and 1942, and their underground chambers beneath one of the moats of Valletta, the Lascaris War Rooms, served as the headquarters for Operation Husky, the Allied invasion of Sicily in 1943.[23] As Marcus Marcellus realized when he stood before Syracuse in 212 BCE, the only way to get in or out of an impenetrable fortress is to enlist help from the inside. The same rule applied for the imprisoned Caravaggio in 1608. He could never have escaped from the Castle of Sant'Angelo all by himself, and he would never have taken the risk without a long-term plan to

return to Naples or Rome. His most likely route out of the fortress would have taken him from its interior down to the underground barracks of the galley slaves, and from there he would have had to walk no more than a few yards to board whatever vessel it was that swept him off to Syracuse on the night of October 6 (Plate 21). Biographers and tour guides often paint a lurid picture of the painter confined in the *guva*, the windowless underground cistern the knights reserved for the men they regarded as their most heinous criminals. But rowdy Knights of St. John, like rowdy sailors, were a normal feature of life on the Maltese islands.[24] Caravaggio, charged at most with helping break down a door, would have been locked in with the other drunks to cool his head and think things over, enclosed behind an obsessive sequence of trick doors and ramps that only an insider could ever have penetrated. Besides, his judges were admirers of his art whose sense of justice, however stern, did not include throwing relatively minor offenders into the cistern.

Who sprang Caravaggio from jail? The prison's director, Fra' Girolamo Carafa, was a Neapolitan relative of his patroness, Costanza Sforza Colonna. The fact that Caravaggio surfaced in Messina might also suggest the influence of Fra' Antonio Martelli, the city's prior, who was also Caravaggio's patron and his judge, or perhaps that of Fabrizio Sforza Colonna, the son of Costanza Sforza Colonna, who had conveyed the painter to Malta in the galley he commanded—the same one that had brought his mother from Genoa to Rome. Some scholars have suggested that Grand Master Wignacourt himself played a role, sentencing Caravaggio to a de facto exile rather than a prison term that would have prevented him from painting (in fact, Caravaggio sent him a painting from Sicily by way of apology).[25]

No matter what the circumstances, the painter's escape from Malta never brought him peace of mind or physical safety. He moved about in fear for the rest of his life, convinced that he was being followed. The enormity of his fall from grace may have unhinged him, but he may also have had good reason for his fears. He may not have been the person who shot Fra' Giovanni Rodomonte Roero, a blue-blooded knight of justice, but he may have incurred Roero's undying wrath during their dustup by a shove or a rude remark. Costanza Sforza Colonna had always been able to save her painter by exploiting the mutual support system of the upper aristocracy, but in taking on an old-school knight of justice, he may have been fighting above his class.

Syracuse is only ninety-two miles from Malta, and it was a logical port of call for the fugitive. Caravaggio could also count on the help of a friend in the city, his former studio assistant Mario Minniti. Born in 1577, six years after his mentor, Minniti was a native of Syracuse. After a quick stay in Malta in 1692, he seems to have moved to Rome, where he lived with Caravaggio (apprentices often lived with their master), and with his dark curly hair, round face, and lively black eyes, he served as a model for many of his master's early works.[26] In 1603, when "Mario the painter" is mentioned in one of Caravaggio's police records, Minniti was living independently in Rome, but by 1606 he was residing in Syracuse, a married man and a master in his own right.[27] Less talented than Caravaggio but infinitely more responsible, he would become one of the most prolific and successful painters in seventeenth-century Sicily.[28]

Shortly after landing in Syracuse, Caravaggio started work on a huge canvas, possibly commissioned by the city's Senate. On

December 6, 1608, he signed a receipt that shows he had moved
on to Messina. Five days after his defrocking in Malta, the doc-
ument still called him "fra Michelangelo Caravagio Knight of
Jerusalem," as it awarded him the astounding sum of one thou-
sand *scudi* (when ten scudi a month were a decent working-
man's salary).[29] He would stay in Messina another few months,
proceed west to Palermo, and from Palermo return to Naples in
the fall of 1609. There, in October, in the famous old inn called
the Cerriglio, he was attacked by a gang of knife-wielding assail-
ants who slashed his face and nearly killed him. The attackers
have been presumed to be hired assassins working for a knight
of Malta, perhaps Roero or even Wignacourt (although there
are strong reasons for supposing that Wignacourt was the per-
son who spirited Caravaggio out of prison and sent him on to
Sicily).[30] Disfigured by the slasher, the painter recovered slowly
in Villa Cellamare, the Neapolitan seaside retreat of his faith-
ful sponsor Costanza Sforza Colonna. Together they worked on
drafting a petition to Cardinal Scipione Borghese, the influen-
tial nephew of Pope Paul V, requesting a papal pardon for the
murder of Ranuccio Tomassoni and Caravaggio's readmission
to the territory of Rome. The petition was eventually granted,
but the painter never heard the good news. He died in the hos-
pital of Porto Ercole, just past the northern border of the papal
state, on July 18, 1610, racked by fever as he waited impatiently
for the pope's verdict.[31] He was not yet thirty-eight years old.

Caravaggio may have been a fugitive in Syracuse, but he
was also famous and noble, for he was still officially a knight
of Malta. It was natural to have him meet another local lumi-
nary, Vincenzo Mirabella—with Galileo Galilei, an early mem-
ber of the Roman scientific academy of the Lincei (the lynxes),

founded in 1603 to foster natural philosophy and today Italy's national honor society.[32] A scientist, mathematician, musician, and poet, Mirabella took the distinguished visitor on a tour of the city that included a stop in the quarries. There the two men marveled at the acoustics of the great cave in the Latomia del Paradiso, and Mirabella recounted the old story of how the tyrant Dionysius eavesdropped on his prisoners. But Caravaggio had his own ideas to contribute.

The following anecdote recounted by Mirabella hinges on the fact that both he and Caravaggio took it for granted that an artist's job, as Aristotle had declared in his *Poetics*, was to imitate nature. In his libel trial of 1603, Caravaggio had been asked to define a *valent'uomo* (a good man) after asserting that several of his rivals were nothing of the sort. He replied: "To me, that word *valent'uomo* means that he knows how to do well, that is, he knows how to carry out his work well, so a painter is a *valent'uomo* if he knows how to paint well and imitate natural things."[33]

For Caravaggio, "imitating natural things" included painting the occasional flying angel, but it also meant rebelling against the aesthetic of elongated bodies and strange pastel colors favored by many of his contemporaries. His conversation with Mirabella reflected their shared awe of nature:

Today you can see that Prison, and whoever considers the skill and industry with which it was made by the Tyrant, so that the prisoners who were in it could hardly even breathe without being overheard by the guards, will be compelled to admire it and to marvel. And I remember when I took that singular painter of our times, Michel

Angelo of Caravagio, to see this prison, he, considering its quality, and moved by that unique talent of his to imitate natural things, said: "Don't you see how the Tyrant, in wanting to create a vessel that would serve to make things heard, took no other model than the one that nature built for the same purpose. And so he made this Prison in the form of an ear." And this fact, never noted before, upon examination, filled the most inquisitive with a double wonder.

[This prison] has been dug into living rock, and by sinuous turns it ends in a narrow channel in its upper reaches, and in that channel, which penetrates to the outside through an opening, around which a guard's chamber was constructed, every tiny movement displaced the air so that it could be heard. Today, the wall that stopped the cave mouth has been removed, and voices no longer travel through the aforementioned channel, but issue forth from the very mouth of the cave, and make a marvelous Echo, and for this reverberation of the voice it is called the Grotto of Speech.

Nor can I fail to mention the wonderful new opportunity this Echo has provided professors of music, who can write a canon for two voices, and with the help of the Echo create a perfect harmony of four voices. My teacher Antonio Falcone was the first to put this effect into practice.[34]

Today Falcone's role in filling the Ear of Dionysius with music is played by Lorenzo Corbé, one of the licensed tour guides for the Parco Archeologico of Syracuse. Rather than a canon, Corbé sings a Sicilian folk melody in a haunting minor

key as old as a threnody of Aeschylus and as mournful as an
Arab love song. When he sings, Plato's cave is no longer a
prison but a bridge across the ages (Plate 22).

The painting that Caravaggio produced so quickly in Syr-
acuse, The *Burial of St. Lucy*, marked a profound change in his
style. His Sicilian paintings were executed quickly, with spar-
ing layers of thin paint, and used starkly diagonal composi-
tions. The Sicilian journalist Marcello Mento has suggested
that what brought the fugitive to Sicily in the first place was
not the intervention of a knightly patron or the shelter of a
friend, but the pull of a long-dead artist: the great fifteenth-
century painter Antonello da Messina (whose work Caravaggio
might have seen en route from Naples to Malta).[35] Knowledge
of Antonello's paintings would certainly help explain Caravag-
gio's experiments with blue around this time, but his painting
for Syracuse concentrates on earth tones, and for good reason.
St. Lucy was buried in an underground catacomb on the out-
skirts of the city, and the painting was designed for the church
that marks her grave, Santa Lucia al Sepolcro.

St. Lucy is the patroness of Syracuse, a native daughter who
was martyred, according to legend, by the Emperor Diocle-
tian in the year 304. The Byzantine poet and grammarian John
Tzetzes claimed that she was descended from Archimedes;[36]
so did David Rivault de Fleurance, the French editor of Archi-
medes' works.[37] Her name (Lucia in Italian) means "light," and
light is her real essence. Before the Gregorian reform of the
calendar in 1583, her feast day, December 13, fell on the win-
ter solstice, the shortest day of the year. Like the maiden Perse-
phone, the ancient patroness of Sicily, Lucy came in glory with
promises of springtime, fertility, and sunlight. The timing of

Caravaggio's October commission, therefore, could not have been more perfect. The painting would be ready for St. Lucy's Day, 1608.

But in Syracuse St. Lucy has taken over not only for Persephone but also for Athena. The grand temple of Athena that stood on the highest point of Ortygia and dominated the ancient agora has become the cathedral church of Syracuse, dedicated to the nativity of the Madonna but with a special chapel reserved for the city's Christian patroness. The lateral walls of the ancient temple's blank cella have been cut to create two arcades framing what is now the central nave of the Christian cathedral. The ancient Doric columns of the peristyle, still visible, have been engulfed by masonry to form the building's exterior walls (Plate 23). Athena's gilded statue on the roof of the temple, whose gleam may have greeted Plato as he arrived in the Small Harbor, is long gone, but since the early seventeenth century a brilliantly shiny statue has taken up residence inside the church, the *Simulacro* of St. Lucy (Plate 24), a life-sized silver statue of the saint who represents the transcendent celestial light of Christian faith.[38] But the imagery of light that surrounds St. Lucy also owes an enormous debt — through St. Paul, the Gospel of John, and St. Augustine — to the same light that Plato described in his allegory of the cave, the light that blinds us when we first encounter it, by filling our eyes with sunshine.[39]

The best-known medieval life of St. Lucy, and the one that would have been most familiar to Caravaggio, comes from the *Golden Legend* of Jacobus de Voragine (1298), which begins with an explicit connection between Lucy and the Latin word for light: "Lucy comes from *lux*, which means light. Light is beautiful to look upon; for, as Ambrose says, it is the nature of light

that all grace is in its appearance. Light also radiates without being soiled; no matter how unclean may be the places where its beams penetrate, it is still clean. It goes in straight lines, without curvature, and traverses the greatest distances without losing its speed. Thus we are shown that the blessed virgin Lucy possessed the beauty of virginity without trace of corruption; that she radiated charity without any impure love; her progress toward God was straight and without deviation, and went far in God's works without neglect or delay. Or the name is interpreted 'way of light.'"[40]

As is the case with many of the saints killed in the reign of Diocletian, a few years before the Roman Empire legalized Christianity, Lucy's story combines a strong local connection with events that are mostly legendary (St. Cecilia in Rome has a similar life story and a similarly close association with a specific city). The *Golden Legend* reports that she was a young noblewoman of Syracuse and that she and her mother, Eutychia, were devoted to St. Agatha—the patron saint of nearby Catania, who had been martyred in 251 in the reign of Trajan Decius.[41] Lucy (like St. Cecilia in Rome) resolves to give all her wealth away to the poor, until her angry fiancé turns her in to the Roman consul Paschasius, denouncing her as a Christian. Paschasius tries to set a mob on Lucy, but she remains rooted to the spot; a thousand oxen cannot move her. He pours urine over her, then boiling oil, and lights a roaring fire around her, but she survives unharmed, chiding him as each new torment fails. Finally, one of the consul's friends plunges a dagger into her throat: "But far from losing the power of speech, she said: "I make known to you that peace has been restored to the Church! This very day [coemperor] Maximian has died, and Diocletian

has been driven from the throne. And just as God has given my sister Agatha to the city of Catania as protectress, so I am given to the city of Syracusa as mediatrix." While the virgin was still speaking, envoys from Rome arrived to seize Paschasius and take him in chains to Rome, because Caesar had heard that he had pillaged the whole province [a distant echo of Cicero's prosecution of Gaius Verres]."[42]

Paschasius, the *Golden Legend* assures us, was condemned to death by beheading. Lucy did not die until she had received communion for the last time. She was buried outside the city walls of Syracuse in the fourth-century Catacombs of Saint John, which had been carved into the same limestone as the quarries.

In late medieval times, the saint took on an added association with eyes. A new episode in her legend asserted either that she had been praised for the beauty of her eyes and plucked them out in modesty, or that Paschasius blinded her as part of her punishment. She is often shown, therefore, with her eyes on a platter, as she is in the *Simulacro*. This statue, executed in Palermo by the sculptor Giovanni Rizzo between 1590 and 1599, also contains relics of the saint. Despite the dagger that pierces her neck, an elegant Lucy smiles serenely, holding a platter containing her eyes in one hand and the palm of martyrdom in the other. On the saint's feast day, her image is paraded through the streets of Syracuse, but Caravaggio never saw it: it took twenty years for the Syracusans to raise enough money to pay for the *Simulacro* and move it from Palermo to its final destination at Santa Lucia al Sepolcro, where it was meant to complement his somber painting. Today, the statue spends its winters in its original home, above the saint's burial place. In the summer,

however, the *Simulacro* occupies a special chapel of the cathedral, to take advantage of the certainty that every visitor to Syracuse will come to the center of Ortygia.

Caravaggio presents a radically different version of St. Lucy in his *Burial of St. Lucy* (Plate 25). His saint is simply dressed. Her eyes are closed in death, but her mouth is open, and we can see her upper teeth. The knife wound that killed her slashes down the right side of her long, graceful neck.

But it is light that provides the transcendent theme of Caravaggio's dark, somber painting. It glances off the faces of her mourners, the armor of a guard, and the shoulders of the two burly gravediggers who dominate the foreground. Most powerfully of all, it shoots in a downward diagonal from the upraised hand of the bishop on the right, who sends his blessing past the folded hands of a young deacon to the glowing face of Lucy (and her painfully exposed slit throat), an invisible current that manages to blaze though the painting like an arrow of light.

The painting, badly damaged by centuries of humidity, looks awkward in reproductions. Lucy's foreshortened arm looks stubby, and the ample rear of the right-hand gravedigger seems to dominate the composition more than it should. But Caravaggio painted the image in situ. He knew how the exaggerated perspective, in its rightful place, would seem to open out the space beyond the picture's surface. The gravediggers would melt into the foreground along with the painting's architectural frame, and Lucy's body, radiating a holiness powerful beyond death, would emerge with crystalline clarity, linked forever with the bishop's symbolic miter and blessing hand, and the folded hands of the faithful deacon who stands in for every viewer who

will ever see the painting. His reverent posture, meanwhile, tells viewers how they should react to this disconcerting scene. Caravaggio urges us to see that what looks like a tragic tableau of death and burial is really an image of light and life triumphing over every form of darkness: an underground cave, human perfidy, and the limits of mortality.

Caravaggio often painted himself into crowd scenes. Here we can almost see him split between the swaggering armored soldier who stands with his back to us, his face flaked away to the hint of a shadow, and the scowling man, barely visible, who looks nervously toward the bishop's blessing hand rather than Lucy's holy body. In recent months, he had been both these people, the arrogant knight and the humble petitioner, whose only hope for absolution lay in the hierarchy of the church and the pardoning power of the pope.

The recent history of the *Burial of St. Lucy* has been as stormy as any episode in Caravaggio's own life. In 1971, the humid conditions in Santa Lucia al Sepolcro began to put the elderly painting in danger. In 1979, it was sent to Rome's Istituto Centrale per il Restauro for restoration. When the canvas was returned to Syracuse in 1983, it was installed in a climate-controlled room in the Regional Art Museum in Palazzo Bellomo, rather than in its original suburban seaside location. For a time, at least, it was displayed in the same room as the other great artistic treasure of Syracuse, Antonello da Messina's ravaged but still marvelous *Annunciation*, providing a unique opportunity to compare two great painters with radically different, but not entirely unrelated, techniques. Both artists drew intently from nature and were fascinated with the effects of light and shadow on surfaces, although Antonello worked in the meticulous Netherlandish

style in tempera on wooden panels, and Caravaggio worked on a much larger scale in oil on canvas. In other respects, however, the conditions at Palazzo Bellomo were not ideal. While the exhibition space worked well for Antonello's much smaller painting, it was too restricted to accommodate the grand scale of Caravaggio's perspective: the executioners loomed too large, and Lucy's short arm looked clumsy rather than clever. The painting was also loaned out to several exhibitions, before returning to the Istituto Centrale per il Restauro in 2005. In spite of strenuous protests by the institute's director, Caterina Bon Valsassina, it journeyed to Milan before the restoration was entirely complete, to appear in a large Caravaggio show mounted in early 2006 at Milan's Palazzo Reale. From there, it returned to Syracuse, to the Centro Regionale del Restauro of the Region of Sicily, where an x-ray analysis showed that 30 percent of the painting's surface had been retouched in previous restoration campaigns.[43] Back it went, yet again, to the Istituto Centrale per il Restauro in Rome.

Upon its return in 2009, in anticipation of the four hundredth anniversary of Caravaggio's death in 2010, the *Burial of St. Lucy* was installed in the church of Santa Lucia alla Badia at the southern end of Ortygia's central Piazza del Duomo; its original home, Santa Lucia al Sepolcro, was still under restoration to reduce humidity. In an unusual procedure, curators simply installed Caravaggio's canvas in front of the existing altarpiece at Santa Lucia alla Badia, inside an iron and steel frame with bulletproof glass, and mounted a special exhibition describing Caravaggio's working methods and the process of restoration.[44] Here, just as in Santa Lucia al Sepolcro, a cavernous interior and gleaming white baroque stucco set the painting

off to perfection. Caravaggio's perspective snaps dramatically into place, and because the setting itself is a consecrated space, the painting still functions as a "working" image for faithful pilgrims as well as more secular art lovers. In fact, the painting fits so well in its new home, and so comfortably on tourist itineraries, that a battle for possession has broken out between the two churches. The structural restorations at Santa Lucia al Sepolcro were completed in 2015. The climatic conditions in the two churches are similar: stone masonry faced with stucco, perennially subject to changes of temperature and the salt and moisture of sea air. Neither is an ideal place, by modern museum standards, for a centuries-old oil painting, but spiritually and visually they are both incomparably better than a climate-controlled gallery with no anchor in space, history, or civic life. At the time of this writing, Santa Lucia al Sepolcro, the original setting for which the painting was created, hopes that its Caravaggio will return home, drawing people to the suburbs of Syracuse as well as the center and helping turn them into thoughtful visitors rather than "grab and go" tourists. At present, the people who come to Syracuse still come in search of archaeological sites, architecture, art, theater, and music; the city is short on beaches and nightlife. But because Santa Lucia alla Badia, a few dozen yards from the cathedral, can count on attracting virtually every person who sets foot in Ortygia, the creators of package tours are delighted to have it where it is (just as the cathedral is delighted to have St. Lucy's *Simulacro* for the summer months). Rhetoric runs high, in the same streets where Gorgias of Leontini plied his trade 2,500 years ago, and Athena reigned with Artemis and Persephone where Lucy would one day rule as the bringer of light. Caravaggio's

Burial of St. Lucy, it has to be said, casts its spell in either venue, but when his paintings still hang where they were designed to hang in Rome, Malta, and Naples, in subtle, unexpected ways their details reveal the full extent of his mastery of light. For the infinitely layered history of Syracuse, and for Caravaggio's art, the *Burial of St. Lucy* belongs at home.

NOTES

<hr>

INTRODUCTION

1 Plutarch, *Life of Nicias*, 29.2.

2 Thucydides, *History*, 8.96.5.

3 A concise account of archaeological discoveries in Piazza del Duomo is available at the website of the Department of Cultural Properties and Sicilian Identity of the Regional Government of Sicily. See Dipartimento di beni culturali e dell'Identità Siciliana, 'Parchi, musei, gallerie e aree archeologiche," accessed 12 November 2017, http://www.regione.sicilia.it/beniculturali/dirbenicult /database/page_musei/pagina_musei.asp?ID=179&IdSito=73.

4 Cicero, *Against Verres*, 2.4.117: "Urbem Syracusas maximam esse Graecarum, pulcherrimam omnium saepe audistis. Est, iudices, ita ut dicitur."

5 Syracuse and the Rocky Necropolis of Pantalica together were designated a UNESCO World Heritage Site in 2005 (UNESCO, World Heritage List, "Syracuse and the Rocky Necropolis of Pantalica," accessed 9 September 2017, http://whc.unesco.org/en/list/1200).

6 Margaret Miles, *Art as Plunder: The Origins of Debate about Cultural Property* (Cambridge: Cambridge University Press, 2008).

7 See Oriana Bandiera, "Land Reform, the Market for Protection and the Origins of the Sicilian Mafia: Theory and Evidence," *Journal of Law, Economics, and Organization* 19, no. 1 (2003): 218–44; Alexander Stille, *Excellent Cadavers: The Mafia and the Death of the First Italian Republic* (New York: Vintage Books, 1996); Diego Gambetta, *The Sicilian Mafia: The Business of Private Protection* (Princeton, NJ: Princeton University Press, 1993).

8 Booker T. Washington, *The Man Farthest Down: A Record of Observation and Study in Europe* (Garden City, NY: Doubleday, 1911), 203. For the conditions in the sulfur mines, see also Renato Malta, *Cercavano la luce: Storia sanitaria delle zolfare di Sicilia* (Bagheria, Italy: Plumelia, 2012). For a fascinating analysis of Washington's trip and his observations about Sicily in *The Man Farthest Down*, see Michel Huysseune, "'This Country, Where Many Things Are Strange and Hard to Understand': Booker T. Washington in Sicily," *RSA Journal* 25 (2014): 173–90.

9 Pius XII, "Radiomessaggio di Papa Pio XII il 17 ottobre 1954—san Giovanni Paolo II a Siracusa," 17 October 1954, accessed 12 October 2017, http://www.madonnadellelacrime.it/pagina.asp?ID=25&Pio _XII_e_san_Giovanni_Paolo_II. For the story of the Madonna delle Lacrime, see *Famiglia Cristiana*, "Madonna delle Lacrime di Siracusa, ecco le cose di sapere," 29 August 2017, accessed 12 October 2017, http://www.famigliacristiana.it/articolo/madonna-delle-lacrime-di -siracusa-le-cose-da-sapere.aspx) and the website of the Sanctuary of the Madonna delle Lacrime, http://www.madonnadellelacrime.it. See also Jenner Meletti, "Un holding da tre miliardi per le madonne piangenti," *La Repubblica*, 1 October 2010, which reports that currently visitors number about eight thousand a month.

1. PLATO AND SYRACUSE

1 Ariston was a *cleruch* (colonist) in Aegina. See Debra Nails, *The People of Plato: A Prosopography of Plato and Other Socratics* (Indianapolis, IN: Hackett, 2002), 54.

2 See Plato, *Parmenides* 126c, where Antiphon's love for horses is traced back to his paternal grandfather, also named Antiphon.

3 William H. F. Altman, *Plato the Teacher: The Crisis of the Republic* (Lanham, MD: Lexington Books, 2012), 66.

4 Plato, *Republic* 368a: παῖδες Ἀρίστωνος, κλεινοῦ θεῖον γένος ἀνδρός.

5 Diogenes Laertius, *Life of Plato*, 3.2.

6 Altman, *Plato the Teacher*, 66–68.

7 Thucydides, *History*, 1.1.1.
8 The *Republic*, like many of Plato's dialogues, is not consistent in its
 historical details; see Debra Nails, "The Dramatic Date of Plato's
 Republic," *Classical Journal* 93, no. 4 (1998): 383–96. The analysis here
 follows Altman, *Plato the Teacher*, 51–54.
9 This is what Lysias, his son, maintains in his *Oration* XII.
10 Deborah Kamen, *Status in Classical Athens* (Princeton, NJ: Princeton
 University Press, 2013), 44–61.
11 The silver and the slaves went together, because Nicias leased out
 the slaves he employed in the mines to others. See Hubert Ashton
 Holden, *Plutarch's Life of Nicias: With Introduction, Notes, and Lexicon*
 (Cambridge: Cambridge University Press, 1867), 63–64; Matthew
 Dillon and Linda Garland, *Ancient Greece: Social and Historical
 Documents from Archaic Times to the Death of Alexander the Great*, 3rd ed.
 (Abingdon, UK: Routledge, 2010), 179–80 and 187. See also Ingrid
 D. Rowland, "An Elegy for Hykkara," in *Nation and World, Church and
 God: The Legacy of Garry Wills*, edited by Kenneth L. Vaux and Melanie
 Baffes (Evanston, IL: Northwestern University Press, 2014), 27–40.
12 Thucydides, *History*, 4.72.1–4; Plato, *Republic* 368a. I take this to be
 the 424 battle of Megara, contra Nails, *The People of Plato*, 3, 164, 246,
 and 325; and Danielle S. Allen, *Why Plato Wrote* (Chichester, UK:
 Wiley-Blackwell, 2010), 165.
13 Plato, *Republic* 327a–c). Compare this to the first interview between
 Sherlock Holmes and John Watson:
 "Dr. Watson, Mr. Sherlock Holmes," said Stamford, introducing us.
 "How are you?" he said cordially, gripping my hand with a
 strength for which I should hardly have given him credit. "You
 have been in Afghanistan, I perceive."
 "How on earth did you know that?" I asked in astonishment
 (Arthur Conan Doyle, *A Study in Scarlet: Being a Reprint from the
 Reminiscences of John H. Watson, M.D., Late of the Army Medical
 Department* (London: Ward, Lock and Co., 1887), 16.
14 Altman, *Plato the Teacher*.
15 Thucydides, *History*, 6.1.1.

16 Thucydides, *History*, 6.15.2–3.

17 Eva C. Keuls made this suggestion in *The Reign of the Phallus: Sexual Politics in Ancient Athens* (Berkeley: University of California Press, 1985), 16–32. See also James Fredal, "Herm Choppers, the Adonia, and Rhetorical Action in Ancient Greece," *College English* 64, no. 5 (2002): 590–612.

18 Thucydides, *History*, 7.84.2–5.

19 Thucydides, *History*, 7.87.1–4.

20 Plutarch, *Life of Nicias*, 29.1–2.

21 Pietro della Valle, *Viaggi di Pietro della Valle, il pellegrino* (Brighton, UK: G. Gancia, 1843), 911: "Il giorno andammo a vedere il convento de' Cappuccini fuor della città, dentro agli orti dei quali si veggono dirupi e concavità profondissime, perchè tutto quel terreno, ch'è di pietra, in tempi antichi è stato cavato per cavarne le pietre; e si scorge esservi siate tagliate colonne bellissime tutte d'un pezzo, come potrebbono anche cavarsene delle altre; ed in quelle profonde oscure valli delle concavità vi sono nondimeno orti ed alberi piantati che fanno frutti bellissimi, il che mi fece maravigliare, perché alcuni ne vidi in luoghi dove non possono esser mai tocchi dal sole, tanto è profondo il terreno, e tanto strettamente serrato da alte rupi d'ogn'intorno. Queste sono le Lapicidine, dove furono messi prigioni gli Ateniesi che dopo aver perduto molte battaglie in terra ed in mare, si resero finalmente ai Siracusani, come narra Tucidide."

22 Thucydides, *History*, 7.27.5. See Thomas R. Martin, *An Overview of Classical Greek History from Mycenae to Alexander*, 12.2.4, accessed 1 August 2017, http://www.perseus.tufts.edu/hopper/text?doc= Perseus%3Atext%3A1999.04.0009%3Achapter%3D12%3Asection %3D2%3Asubsection%3D4.

23 Luciano Canfora, *La guerra civile ateniese* (Milan: Rizzoli, 2013).

24 See Kenneth J. Dover, *Lysias and the Corpus Lysiacum* (Berkeley: University of California Press, 1968), 52.

25 Canfora, *La guerra civile ateniese*.

26 Ibid. and Luciano Canfora, *Tucidide. La menzogna, la colpa, l'esilio* (Bari, Italy: Laterza, 2016).

27 Thucydides, *History*, 8.97.2.

28 Plato, *Seventh Letter*, 324 a–d.

29 Plato details the charges in his *Apology*, 24b–c.

30 Plato, *Seventh Letter*, 325 a–c.

——————

2. PLATO IN SYRACUSE

 1 Luigi Pareti, *Storia della popolazione lucano-bruzzia nell'antichità, opera inedita a cura di Angelo Russi* (Rome: Edizioni di Storia e Letteratura, 1998), 26. Pareti's manuscript was written in 1961 but not published until 1998.

 2 Walter Burkert, *Lore and Science in Ancient Pythagoreanism* (Cambridge, MA: Harvard University Press, 1972), 195.

 3 Walter Burkert, "Platon oder Pythagoras? Zum Ursprung des Wortes 'Philosophie,'" *Hermes* 88, no. 2 (1960): 159–77.

 4 Plato, *Seventh Letter*, 327a–b.

 5 Diodorus Siculus, *Library*, 14.7–9 and 15.15–17.

 6 Ibid., 13.96.5.

 7 Ibid., 13.75.2–8. See also Tim Rood, "Xenophon and Diodorus: Continuing Thucydides," in *Xenophon and His World: Papers from a Conference Held in Liverpool, July 1999*, ed. Christopher Tuplin (Stuttgart, Germany: Franz Steiner Verlag, 2004), 360–64.

 8 For more on Hermocrates, see Rood, "Xenophon and Diodorus"; C. M. Fauber, "Hermocrates and Thucydides: Rhetoric, Policy, and the Speeches in Thucydides' *History*," *Illinois Classical Studies* 26 (2001): 37–51; Daniel P. Tompkins, "Gorgias in the Real World: Hermocrates on Interstate Stasis and the Defense of Sicily," in *Kinesis: The Ancient Depiction of Gesture, Motion, and Emotion*, ed. Christina Clark, Edith Foster, and Judith P. Hallett (Ann Arbor: University of Michigan Press, 2015), 116–26.

 9 Pausanias, *Guide to Greece*, 5.7.1–3.

10 Pindar, *Nemean Odes*, 1.1–6.

11 Aelian, *Varia Historia*, 12.44.

12 Plato, *Republic*, 514a–b.

13 The ancient Greek word for marionettes is *neurospastai* (moved by strings). Here Plato writes *thaumatopoioi* (spectacle makers).

14 The UNESCO application to include Karaghiozi puppets as part of the Greek "intangible cultural heritage" appears online with information about the Peloponnesian Folklore Foundation (UNESCO, "Accredited NGOs Located in This Country," accessed October 15, 2017, https://ich.unesco.org/en/state/greece-GR?info= accredited-ngos).

15 Plato, *Republic*, 514b–515b.

16 Plato, *Republic*, 515c–d.

17 Plato, *Republic*, 517a–b.

18 John Henry Wright, "The Origins of Plato's Cave," *Harvard Studies in Classical Philology* 17 (1906): 131–42; Charles Heald Weller, "The Cave at Vari. I. Description, Account of Excavation, and History," *American Journal of Archaeology* 7, no. 3 (1903): 263–88.

19 Diodorus Siculus, *Library*, 15.6.2.

20 Ibid., 15.6.3.

21 Ibid., 15.6.5.

22 Plutarch, *Life of Dion*, 5.

23 Diogenes Laertius, *Life of Plato*, 20.

24 Diodorus Siculus, *Library*, 15.74.1–4.

25 Plutarch, *Life of Dion*, 6.

26 Plato, *Seventh Letter*, 326b–27a.

27 R. E. Wycherley, "Peripatos: The Athenian Philosophical Scene—II," *Greece and Rome* 9, no. 1 (1962): 1–10.

28 Plato, *Republic*, 519b–520a.

29 Sophocles, *Oedipus at Colonus*, 668–706.

30 Several late antique and medieval biographies of Aristotle report this detail. See Anton-Hermann Chroust, *Aristotle: New Light on His Life and on Some of His Lost Works* (London: Routledge Library Editions, 2015), 1:104.

31 Plato, *Seventh Letter*, 327b–328c.

32 Ibid., 326b–c.

33 Plutarch, *Quaestiones convivales* (Table Talk), 1.10.1.

34 "Pros hêdonên" (Plato, *Symposium*, 176e).

35 For Ficino's role in Neoplatonism, see, amid a vast bibliography, Brian P. Copenhaver, "Scholastic Philosophy and Renaissance Magic in the De vita of Marsilio Ficino," *Renaissance Quarterly* 37, no. 4 (1984): 523–54, and *Magic in Western Culture: From Antiquity to the Enlightenment* (Cambridge: Cambridge University Press, 2015), 55–156. The almond cookies appear in Marsilio Ficino, *Marsilius Ficinus De triplici vita* (Paris: Georg Wolff et Johann Philippi, 1489).

36 Plato, *Seventh Letter*, 329b–30b.

37 Plutarch, *Life of Dion*, 17.1 and 22.1.

38 Plato, *Third Letter*, 317b.

39 Plutarch, *Life of Dion*, 22.2.

40 Chroust, *Aristotle*, 1:273, note 123.

41 Plutarch, *Life of Dion*, 19.5–20.2.

42 Diodorus Siculus, *Library*, 16.65–69; Plutarch, *Life of Timoleon*, 1–3.

43 The most strenuous recent case for the letter's inauthenticity is made by Myles Burnyeat and Michael Frede, *The Pseudo-Platonic Seventh Letter*, ed. Dominic Scott (Oxford: Oxford University Press, 2015). The general consensus among scholars is that the letter, even if not written by Plato, comes from Platonic circles and was composed shortly after his death. See, for example, George Boas, "Fact and Legend in the Biography of Plato," *Philosophical Review* 57, no. 5 (1948): 439–57; G. E. R. Lloyd, "Plato and Archytas in the 'Seventh Letter,'" *Phronesis* 35, no. 2 (1990): 159–74; T. H. Irwin, "Plato: The Intellectual Background," in *The Cambridge Companion to Plato*, ed. Richard Kraut (Cambridge: Cambridge University Press, 2006), 51–88; V. Bradley Lewis, "The Rhetoric of Philosophical Politics in Plato's 'Seventh Letter,'" *Philosophy and Rhetoric* 33:1 (2000): 23–38.

44 Plato, *Seventh Letter*, 341 c–d.

45 Ibid., 336 b–c.

46 For an excellent overview of the chronology of these dialogues, see Catherine H. Zuckert, *Plato's Philosophers: The Coherence of the Dialogues* (Chicago: University of Chicago Press, 2009), 4–8 and 420–69.

47 Ibid., 428–30.

48 Plato, *Timaeus*, 26e.

49 Ibid., 17.9.

50 Zuckert, *Plato's Philosophers*, 429–30.

3. ARCHIMEDES IN SYRACUSE

1 Polybius, *Histories*, 8.6. Quotations are from Polybius, *Histories*, trans.
Evelyn S. Shuckburgh (London: Macmillan, 1889). Future quotations
from this work will be cited parenthetically in the text.

2 The term appears in Baldassare Castiglione, *Il Cortegiano* (The book
of the courtier) (Venice: Aldus Manutius, 1528), book 1, chapter 26.
For Castiglione's understanding of *sprezzatura*, see Harry Berger
Jr., *The Absence of Grace: Sprezzatura and Suspicion in Two Renaissance
Courtesy Books* (Stanford, CA: Stanford University Press, 2000). For
a lighter touch, see Peter d'Epiro and Mary Desmond Pinkowish,
Sprezzatura: 50 Ways in which Italian Genius Shaped the World (New York:
Anchor Books, 2001).

3 For the significance of the joke as a key to the characters of both
Marcellus and Archimedes, see Mary K. Jaeger's brilliant analysis
in *Archimedes and the Roman Imagination* (Ann Arbor: University of
Michigan Press, 2008), 116–20.

4 R. T. Ridley, "To Be Taken with a Pinch of Salt: The Roman
Destruction of Carthage," *Classical Philology* 81, 2 (1986): 140–46.

5 Vitruvius, *Ten Books on Architecture*, 10.16.12.

6 Ibid., 10.16.2.

7 Jaeger, *Archimedes and the Roman Imagination*, 77–101.

8 Vitruvius, *Ten Books on Architecture*, 9.praef.4.

9 Ibid., 9.praef.9.

10 Ibid., 9.praef.3.

11 Adam Lajtar, "The Cult of Amenhotep Son of Hapu and Imhotep
in Deir el-Bahari in the Hellenistic and Roman Periods," in *"Et
maintenant ce ne sont plus que des villages . . ." Thèbes et sa région aux
époques hellénistique, romaine et byzantine. Actes du colloque tenu à
Bruxelles, les 2–3 décembre 2005, Papyrologica Bruxellensia*, vol. 34, ed.

A. Delattre and P. Heilporn (Brussels: Association Égyptologique Reine Élisabeth, 2008), 113–23.

12 Plutarch, *Quaestiones convivales*, 8.2. The passage presents some textual problems, but the basic sense is that given here. The existing English translations omit the passage about rationals and irrationals.

13 The manuscripts of Archimedes' *Sand-Reckoner* read the nonsensical "Pheidias Akoupatros." The emendation "Pheidias emou patros" (Phidias my father) was first proposed by the German classicist Friedrich Blass ("Der Vater des Archimedes," *Astronomische Nachrichten* 104, 16 [1883]: 255–56) and has been generally accepted.

14 Jaeger, *Archimedes and the Roman Imagination*, 6.

15 Bridget Leach and John Tait argue that the material was introduced to Syracuse in the third century BCE ("Papyrus," in *Ancient Egyptian Materials and Technology*, ed. Paul T. Nicholson and Ian Shaw [Cambridge: Cambridge University Press, 2000], 236).

16 Plutarch, *Life of Marcellus*, 17.6. See also Jaeger, *Archimedes and the Roman Imagination*, 102 and 118; Alan Hirshfeld, *Eureka Man: The Life and Legacy of Archimedes* (New York: Walker Books, 2009), 13.

17 Frank J. Swetz, "Mathematical Treasure: The Archimedes Palimpsest," Mathematical Association of America, accessed 9 September 2017, https://www.maa.org/press/periodicals /convergence/mathematical-treasure-the-archimedes-palimpsest. See also "The Archimedes Palimpsest," accessed 16 October 2017, http://archimedespalimpsest.org/about/.

18 The palimpsest has now been published as Archimedes, *The Archimedes Palimpsest*, ed. by Reviel Netz, William Noel, Nigel Wilson, and Natalie Tschernetska (Cambridge: Cambridge University Press, 2011), 2 vols. See also Reviel Netz and William Noel, *The Archimedes Codex* (London: Weidenfeld and Nicolson, 2007).

19 For a uniquely expert account of Archimedes and his works, see Giovanni Vacca and Enrico Fermi, "Archimede," *Enciclopedia Italiana* (Rome: Treccani, 1929), accessed 13 November 2017, http://www .treccani.it/enciclopedia/archimede_%28Enciclopedia-Italiana %29/. See also Giovanni di Pasquale and Claudio Parisi Presicce,

Archimede. Arte e scienza dell'invenzione (Rome: Giunti, 2013); Eugenio
Lo Sardo, ed., *Eureka. Scienza e prodigi da Archimede a Plinio* (Naples:
De Luca, 2005). For more on Archimedes as a learned poet, see
Geoffrey Benson, "Archimedes the Poet: Generic Innovation and
Mathematical Fantasy in the Cattle Problem," *Arethusa* 47, no. 2
(2014): 169–96.

20 Niccolò Gherardini claims that Galileo studied Archimedes' work
with Ostilio Ricci, a teacher at the Florentine Accademia del
Disegno (*Vita del signor Galileo Galilei*, in Galileo, *Le opere di Galileo
Galilei*, ed. Antonio Favaro [Florence: Barbéra, 1907], 19:36, 604–5,
and 636–38). In a letter, Galileo calls Archimedes "mio maestro"
(Galileo, *Opere* [Florence: Barbéra, 1905], 16:399).

21 See Jaeger, *Archimedes and the Roman Imagination*, 17–31.

22 Athenaeus, *Deipnosophistae*, 5.40–44.

23 D. L. Simms, "Archimedes and the Burning Mirrors of Syracuse,"
Technology and Culture 18, no. 1 (1977): 5–6.

24 Christopher Haas, *Alexandria in Late Antiquity: Topography and Social
Conflict* (Baltimore, MD: Johns Hopkins University Press, 1997), 144.

25 Ingrid D. Rowland, "Three Seaside Wonders: Pharos, Mausoleum,
and Colossus," in *A Companion to Greek Architecture*, ed. Margaret M.
Miles (Hoboken, NJ: Wiley-Blackwell, 2016), 440–54.

26 Athanasius Kircher, *Ars magna lucis et umbrae* (Rome: Ludovico
Grignani, 1646), 758.

27 Ibid., 765.

4. CARAVAGGIO IN SYRACUSE

1 Caravaggio is termed "egregius in Urbe Pictor" in his contract
for painting two panels for the Cerasi Chapel in Santa Maria del
Popolo. See Helen Langdon, *Caravaggio: A Life* (London: Pimlico,
1999), 179. Langdon's work is still the best, and the best-documented,
biography of the painter.

2 Ibid., 28. This fascinating woman still needs scholarly investigation.

3 Ibid., 21–25. See also Stefania Macioce, "Per una biografia di Cara-

vaggio," in *Caravaggio: Catalogo della Mostra, Roma, Scuderie del Quiriale 20 febbraio–13 giugno 2010*, ed. Claudio Strinati (Milan: Skira), 236.

4 Langdon, *Caravaggio*, 10–12.

5 Mario Tosi, *La società romana dalla feudalità al patriziato* (Rome: Edizioni di Storia e Letteratura, 1968).

6 Wignacourt is the most likely person to have invited Caravaggio to Malta. See Langdon, *Caravaggio*, 340–55.

7 Martha Pollak, *Cities at War* (Cambridge University Press, 2010), 157–63.

8 Langdon, *Caravaggio*, 351.

9 Eric Fenech Sevasta, "L'enigmatico Cassarino and Regional Caravaggism in Early 17th-Century Malta," PhD diss., University of Malta, 2016.

10 Langdon, *Caravaggio*, 352.

11 "Catholic pirates" is what Molly Greene calls them in her *Catholic Pirates and Greek Merchants: A Maritime History of the Early Modern Mediterranean* (Princeton, NJ: Princeton University Press, 2010).

12 Langdon, *Caravaggio*, 343–44 and 353.

13 Ibid., 352.

14 Ibid., 353.

15 Quoted in ibid., 355–56.

16 The classic study on the symbolic meaning of Apelles is Ernst Gombrich, *The Heritage of Apelles: Studies in the Art of the Renaissance* (Ithaca, NY: Cornell University Press, 1976).

17 Keith Sciberras, "'Frater Michael Angelus in Tumultu': The Cause of Caravaggio's Imprisonment in Malta," *Burlington Magazine* 144, no. 1189 (2002): 229–32.

18 Langdon, *Caravaggio*, 356–59.

19 Sciberras, "'Frater Michael Angelus in Tumultu,'" 230.

20 Ibid.

21 As Sciberras so colorfully puts it (ibid.).

22 Ibid.

23 Ernle Bradford, *The Great Siege: Malta 1565* (New York: Harcourt, Brace, and World, 1962).

24 For a list of crimes committed by the knights, see Carmel Cassar,

"1564–1696: The Inquisition Index of Knights Hospitallers of the Order of St. John," *Melita Historica* 11, no. 2 (1993): 157–96.

25 Langdon suggests that Caravaggio's escape was arranged by Fabrizio Sforza Colonna or Wignacourt (*Caravaggio*, 363).

26 The Sicilian painter Francesco Susinno included a biography of Minniti in his *Lives of the Painters of Messina* of 1724. The manuscript, believed lost, was found in the Basel Art Museum by Valentino Martinelli. It was published as Francesco Susinno, *Le Vite de' Pittori Messinesi (1724)*, ed. with an introduction and bibliographical note by Valentino Martinelli (Florence: Felice Le Monnier, 1960). Minniti also appears in contemporary documents, including the police reports involving Caravaggio. For an excellent and superbly documented account of his life, see Donatella Spagnolo, "Minniti, Mario," in *Dizionario biografico degli italiani*, ed. Mario Caravale (Rome: Istituto Della Enciclopedia Italiana, 2010), 72:664–68, accessed 13 November 2017, http://www.treccani.it/enciclopedia/mario -minniti_(Dizionario-Biografico)/.

27 His first documented commission dates from July 1608, a week before the murder of Ranuccio Tomassoni. See Spagnolo, "Minniti, Mario," 72:665.

28 Ibid., 72:665–67.

29 Langdon, *Caravaggio*, 369–76.

30 Andrew Graham-Dixon, following Sciberras's research in Malta (cited above), blames Fra Giovanni Rodomonte Roero for the attack (*Caravaggio: A Life Sacred and Profane* [London: Penguin, 2011], 256). Similarly, Vincenzo Pacelli argues that there was a plot by the Knights of Malta, who had the tacit consent of the Curia (*L'ultimo Caravaggio; Il giallo della morte: omicidio di Stato?* (Todi, Italy: Ediart, 2002). See also Vincenzo Pacelli and Gianluca Forgione, *Caravaggio tra arte e scienza* (Naples: Paparo Edizioni, 2013).

31 Langdon, *Caravaggio*, 389–91.

32 Francesca Fausta Gallo, "Mirabella, Vincenzo," in *Dizionario biografico degli italiani*, 72:762–64, accessed 13 November 2017, http://

www.treccani.it/enciclopedia/vincenzo-mirabella_(Dizionario
-Biografico)/.

33 Caravaggio's testimony appears on the website of the Archivio di
Stato di Roma, where the original documentation is found. See
"Il processo del 1603," accessed 13 November 2017, http://www
.archiviodistatoroma.beniculturali.it/index.php?it/237/il-processo
-del-1603.

34 Vincenzo Mirabella, *Dichiarazione della Pianta dell'antiche Siracuse*
(Naples: Lazaro Scorriggio, 1613), 89.

35 Marcello Mento, "Perché Caravaggio venne a Messina?," *Gazzetta
del Sud online*, 23 February 2017, accessed 19 August 2017, http://
www.gazzettadelsud.it/blog/la--linea-d-ombra/226260/perche
-caravaggio-venne-a-messina.html.

36 John Tzetzes, *Encomium of St. Lucy*, in A. Papadopoulos-Kerameus,
Varia Graeca Sacra (repr., Leipzig: Teubner, 1975), 80–97. See also
Ruth Macrides and Paul Magdalino, "The Fourth Kingdom and the
Rhetoric of Hellenism," in *The Perception of the Past in 12th Century
Europe*, ed. Paul Magdalino (London: Bloomsbury, 1992), 153–54.

37 David Rivaltus a Flurantia, *Archimedis Opera quae extant* (Paris: Apud
Claudium Morellum, 1615), 11: "Qui enim vitas eorum qui in Sicilia
pro Christo martyrium passi sunt, Graece scripsere Divam Luciam,
Divam inquam Gallis nec minus quam Syracusis suspiciendam, cui
puta sacro die huius regni restaurato, lumen & columen Magnus
ille HENRICUS tuae Majestatis (Domine) [addressed to Louis XIII
of France and referring to Henri IV] aeternum colendus Pater
natus est ab antiqua Archimedis stirpe ortam memorant, quod me
primum docuit eruditissimus Graecus Alexandros o basilopolis,
cuius in Sicilia strictissima sum amicitia usus, quique gesta divorum
Siculorum Divarumque e lingua vulgari Graeca, in Latinum
convertit."

38 For the temple, see most recently Richard Evans, *Ancient Syracuse:
From Origin to Fourth-Century Collapse* (New York: Routledge, 2016),
42. For the *Simulacro*, see Basilica di S. Lucia al Sepolcro, "Santa

Lucia—Il simulacro," accessed 18 October 2017, http://www
.basilicasantalucia.com/SLuciaIlSimulacro.aspx.

39 See, for example, Peter Brown, *Augustine of Hippo: A Biography*, new
ed. with an epilogue (Berkeley: University of California Press, 2000),
79–92.

40 Jacobus de Voragine, *The Golden Legend: Readings on the Saints*, trans.
William Granger Ryan, with an introduction by Eamon Duffy
(Princeton, NJ: Princeton University Press, 2012), 27.

41 Paul Oldfield, "The Medieval Cult of St. Agatha of Catania and the
Consolidation of Christian Sicily," *Journal of Ecclesiastical History*
62, no. 3 (2011): 439–56. St. Agatha has a special association with
Mount Etna.

42 Voragine, *The Golden Legend*, 29.

43 The restoration history of the *Burial of St. Lucy* is described in
Siracusa Turismo, "'Il seppellimento di S. Lucia' di Caravaggio,"
accessed 18 October 2017, http://www.siracusaturismo.net/scheda
.asp?ID=215.

44 See ibid.

INDEX